The ATLANTA Ripper

The ATLANTA Ripper

The Unsolved Case
of the Gate City's
Most Infamous Murders

Jeffery Wells

Published by The History Press
Charleston, SC 29403
www.historypress.net

Copyright © 2011 by Jeffery Wells

All rights reserved

First published 2011

Manufactured in the United States

ISBN 978.1.60949.381.3

Library of Congress Cataloging-in-Publication Data

Wells, Jeffrey C.
The Atlanta Ripper : the unsolved case of the Gate City's most infamous murder / Jeffrey Wells.
p. cm.
"Atlanta Ripper Murders."
Includes bibliographical references.
ISBN 978-1-60949-381-3
1. Serial murderers--Georgia--Atlanta. 2. Atlanta (Ga.)--History. I. Title.
HV6534.A7W45 2011
364.152'32092--dc23
2011025751

Notice: The information in this book is true and complete to the best of our knowledge. It is offered without guarantee on the part of the author or The History Press. The author and The History Press disclaim all liability in connection with the use of this book.

All rights reserved. No part of this book may be reproduced or transmitted in any form whatsoever without prior written permission from the publisher except in the case of brief quotations embodied in critical articles and reviews.

This book is dedicated to the women who needlessly lost their lives on the streets of Atlanta during the epic known as the Atlanta Ripper Murders and to Mary Yedell and Emma Lou Sharpe, who both lived to tell about their encounters with the ruthless murderer. What you must have had to endure each night in your dreams would be a curse that should not be wished on any mortal.

In addition, I would like to dedicate this book to the man who taught me how to ride a bicycle and drive an automobile, my grandfather James Taylor. Your love, guidance and wisdom helped me learn how to stand on my own two feet and face the world. Thank you for your many years of hard work and dedication to all of us. You are gone but not forgotten!

Our good people are under the bondage of a narrow theology. Each man is bent on saving his own soul. The only way to save one's soul is by saving the soul of another.

—Reverend Dr. Henry Hugh Proctor, 1917

Contents

Acknowledgements	11
Introduction	13
1. Time and Place: Atlanta in the Early 1900s	17
2. The Ripper Phenomenon	26
3. 1911: The Year of the Atlanta Ripper	30
4. Beyond 1911	72
5. Theories Abound	91
Epilogue	97
Notes	103
Further Reading	109
About the Author	111

Acknowledgements

As with any project, it was impossible to accomplish the research, writing and publishing of this book alone. First, I would like to express my continued appreciation for The History Press. Not only were they kind in accepting the proposal for this book, but they were also an excellent partner in the publication of my first book, *In Atlanta or in Hell: The Camp Creek Train Crash of 1900*.

In addition, I would like to thank those who have supported my efforts throughout the writing of this book. First, I would like to thank my photographer and best friend, Russ Gowin. The pictures are excellent, and I am more than grateful to you for taking your weekend time to help me track down the areas where these murders took place and get those photos. I am also grateful to Rebecca and Karen for agreeing to tag along with us to find those locations. I never knew there were so many little neighborhoods in Atlanta where you could easily get lost. Thank you to all three of you for helping me with that part of the project.

I am also continually grateful to the library associates at Georgia Military College. Their foresight in bringing the *Atlanta Constitution* historical database to our college library has not only helped me teach my college classes better but has also given me a venue through which I can research topics such as the one covered in this book. My gratitude is also extended to the director of our campus in Fairburn, Debbie Condon, and our dean, Roy McClendon. Your continued confidence in

my abilities and support of my writing have been key to my being able to complete this project and numerous others.

I would also like to offer my thanks to Susan Prosser, our campus librarian. Her enthusiasm for my work, as well as her assistance in tracking down articles and other sources, has been important as I trudged along the pathway that led to this work.

Finally, I would like to thank the gang at Bell, Book and Candle in McDonough. To Caprice and the Asbury family, I would like to offer my thanks for always encouraging me and opening your bookstore to me and my friends. Thank you for always providing a venue for my book signings and continued moral support during them. To Dan and Jan, thank you for being such lovers of books and history. Without encouragement from you, I would never have wanted to take the dive into local and regional history.

Introduction

For anyone paying attention in the last few decades, the growth of Atlanta has been phenomenal. From its beginnings as the terminus of the Western and Atlantic Railroad to its being named as the home of the 1996 International Olympic Games, the story of Atlanta is one that would not really have been imagined by even the most gifted of fiction writers. Like any other metropolis, the city has its glistening, beaming skyscrapers towering above the landscape; its heavily trafficked interstates crisscrossing the terrain; its millions of citizens commuting by car, by rail and on foot to their work destinations throughout the area; and, unfortunately, its seedy history chock full of deceit, mayhem, racial unrest and murder. These pages of its history, though unpleasant, have long attracted those who not only enjoy a good reading of local history but who also like a good crime story or murder mystery. It is in these pages that our story begins.

In the early years of the twentieth century in Atlanta, the African American community was rocked by many tragic happenings. Among those was the notorious 1906 Atlanta Race Riot. However, a few years after this tumult, there was born a crime spree that ended in the deaths of a few dozen women in the African American community. Because of the nature of the killings, as well as the number of them, many in the press began to refer to these murders as the work of an "Atlanta Ripper." One must not forget that the murders were only separated from the series of killings in

INTRODUCTION

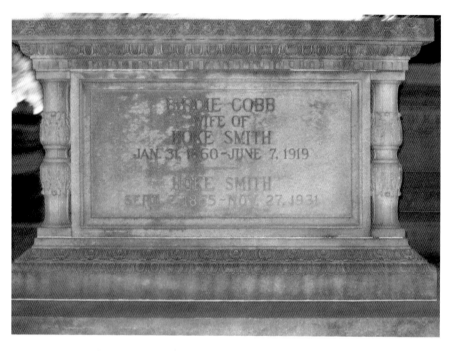

The grave of Governor Hoke Smith, whose racial politics in 1906 contributed to the deadly race riot in Atlanta.

London's White Chapel district by a mere twenty-one years, for those who believe the Atlanta series of killings started in 1909, and twenty-three years for those who believe it started later, in 1911. Nevertheless, the thin passage of time between the London spree and that in Atlanta led many to hang that moniker on the murderer behind the killings in the Gate City.

Once again, there is much discussion about whether these murders began earlier than 1911, but what is not contested is the effect this killing spree had on the city and its citizens, particularly in the black community. For months, even years, the young women of the Gate City were afraid to leave their homes after dark, and some feared to tread the city streets even during daylight hours. Leaders in the African American community began to unite in their insistence that the Atlanta Police Department commit as many resources as possible to tracking down the killer(s) and putting an end to the reign of terror in their community. It was not long before the mayor of Atlanta, Courtland Winn, and the governor of Georgia, Hoke Smith, joined in this effort.

Introduction

As 1911 progressed, the streets of Atlanta became the scene for murder after murder. The Ripper's victims were all young black or mulatto women in their twenties. While there were no fewer than six men arrested for the crimes, it was never ascertained whether the killings were the work of one man or the work of multiple men, including the ones who were arrested and tried for the murders. At least one man was convicted of one of the murders, although it is uncertain based on the news reports which murder he was said to have committed and for which one he was convicted. As the days turned into years, the murders continued, although with less frequency. It was believed that by 1914, the last of the Ripper murders had been committed; however, newspaper reports as late as 1924 attributed brutal slayings of black women in Atlanta to the Ripper.

Most people have never heard of the Atlanta Ripper murders. When discussing crimes of this nature that appear in the annals of Atlanta history,

This photo shows modern-day downtown Atlanta. The city is now a bustling metropolis with over half a million residents. The metro area is over four million strong.

most people immediately think of the Atlanta Youth Murders or the Leo Frank/Mary Phagan episode. The word "Ripper" conjures up images of London's most notorious fiend, Jack the Ripper. Rarely have I discussed the topic of this book with anyone who recognized the subject. There are a few books that have been written on murders in Atlanta, and invariably, some of those have covered the Ripper epoch. One of those was Corinna Underwood's *Murder and Mystery in Atlanta*. She devotes a few pages to the murders in a chapter entitled "Copycat Killer: The Atlanta Ripper." As would be expected, there are numerous books and articles written about crime in Atlanta, specifically murder. One text that comes to mind is James Jenkins's *Murder in Atlanta: Sensational Crimes that Rocked the Nation*.

I first was introduced to the idea of the Atlanta Ripper through reading an article in *Creative Loafing*. In that article, Steve Fennessy did a rather decent job of providing the reader with an overview of the events that were part of the Ripper phenomenon in Atlanta. Of course, his article provided a starting point for my research. I began to dig a little deeper into the history of the city, specifically by looking at the works of men like Franklin Miller Garrett, the author of *Atlanta and Environs: A Chronicle of Its People and Events*. In addition, Rebecca Burns's book *Rage in the Gate City: The Story of the 1906 Atlanta Race Riot* provided a good understanding of the racial tension that existed in the city at the turn of the century. Always trustworthy are the articles found in *The New Georgia Encyclopedia*. This online encyclopedia of Georgia history, geography, culture and society, created by the Georgia Humanities Council, has been a useful tool in my research in the past, and for this project, Andy Ambrose's article "Atlanta" was no less useful than I had hoped it would be.

Other academic databases that were quite helpful were ABC-CLIO's *The African American Experience* and *American History*. Both provided good, scholarly articles about the history of Atlanta and the nation at the time of the murders. *The African American Experience* most especially helped me understand the social, cultural, economic and political experiences of African Americans in Atlanta and the United States during the early years of the twentieth century. However, the pivotal sources for my research were the many articles from the *Atlanta Constitution*. These primary sources provided much detail about the murders, the suspects and the investigations conducted in Atlanta in response to the murders.

1
TIME AND PLACE
Atlanta in the Early 1900s

Before diving into the actual murders themselves, it is important to understand the time and place in which these events occurred. While it may be easy to associate Atlanta today with skyscrapers, amusement parks, professional athletic teams and, unfortunately, long commutes and jammed interstates, the Atlanta of the Ripper murders was much different. The massive urban sprawl that is evident in the city today was not always the case. As a matter of fact, Atlanta in the early 1900s was a tighter-knit community than one might think.

ATLANTA IS BORN

Atlanta actually owes its existence to railroads—ironically, the place near where more than a few of the Ripper's victims were found. At that time, the State of Georgia owned the Western and Atlantic Railroad. By 1837, a few engineers from the Western and Atlantic staked out a place a few miles from the banks of the Chattahoochee River to locate the southern end of a rail line they hoped to build that would connect to Chattanooga, Tennessee. The location of this "end of the line" was billed as Terminus, although the city was not incorporated at this time. In 1843, the name of the community was officially changed to Marthasville in honor of Governor Wilson Lumpkin's daughter,

Martha Lumpkin Compton. She is interred at Atlanta's historic Oakland Cemetery. In 1845, the city was officially renamed Atlanta, the feminine version of Atlantic, a name that reflected the hamlet's destination as the end of the Western and Atlantic Railroad.

Immediately upon its founding, Atlanta charted a different course from the rest of the larger cities in Georgia. While the slave population in many of those cities, like Savannah and Macon, was significant, Atlanta's slave population was much smaller. The economy of the city was also controlled by merchants and those associated with the railroad industry, unlike the older cities of Georgia, whose economies were fueled by plantations and smaller farms. This type of economy would serve Atlanta well in the future, but it did make the city a target during the Civil War. In that epic conflict, Atlanta not only served as a transportation center but also provided a base of manufacturing. Located in the city were the Atlanta Arsenal and the Gate City Rolling Mills. The Atlanta Arsenal provided ordnance and other supplies for the Confederate armies that were fighting in Georgia, Tennessee and Alabama, while the Gate City Rolling Mills produced iron that could be turned into rails. In addition to these resources, Atlanta also had a Confederate hospital and military quartermaster depot. Other industries located in the city were the Atlanta Sword Manufactory and Spiller and Burr, a pistol factory.

As with any city that offered job opportunities in the manufacturing sector, the population of Atlanta swelled. In 1860, there were nine thousand people living in Atlanta, but by 1865, that number had swollen to over twenty-two thousand—a testament to the pull of the industrial base that was starting to form there.

The Civil War Comes to Atlanta

Although it had been of strategic importance to the Confederacy throughout the war years, Atlanta really did not see much of the action of the war until the arrival of one of the most famous figures that came out of the conflict—General William Tecumseh Sherman. In early 1864, Sherman received orders from General Ulysses S. Grant to push as far into the interior of Georgia as he could and inflict as much damage as

possible on the Confederacy's war resources there. Leaving Chattanooga shortly thereafter, he began his march toward Atlanta—a city he claimed did more to damage the Union cause than any other city except Richmond, Virginia. Engaging Confederate troops in General Joseph E. Johnston's Army of Tennessee, he pushed onward, winning battle after battle, including those at Dalton, Resaca, New Hope Church, Atlanta and Jonesboro. The only Confederate victory came at Kennesaw Mountain, but it proved to be hollow, as Sherman was still able to regroup and push forward.

The Union general entered Atlanta on September 2, 1864. The city had been pounded by Union artillery for forty days, resulting in much destruction to the city's businesses, infrastructure and residential sections. Sherman and his army remained in Atlanta until they began their infamous March to the Sea on November 15, 1864. Before leaving, however, Sherman ordered that public buildings, blacksmith shops, factories, railroad facilities and any other places that might aid the Confederate war effort be leveled and set afire. Union troops, eager to destroy the "workshop of the Confederacy," began to set buildings ablaze before they could be leveled, a decision that caused fire to spread and destroy many private homes and buildings not targeted for destruction.

The Phoenix Rises from the Ashes

With only $1.64 of useless Confederate money in the city's treasury after the occupation of Federal troops, the citizens of Atlanta started the long process of rebuilding. As they had done prior to the Civil War, railroads once again provided the economic impetus to make Atlanta a thriving city of commerce, but this time, the growth would be much more painful. Over the next few months, the city's rail lines were running again. Soon, there were no fewer than 150 trains arriving in the city daily. Not long afterward, the city would boast that it was the "Gate City" and the "Chicago of the South."

The thriving railroad industry also led to the redevelopment of commerce and manufacturing in Atlanta. As Georgia had been a productive cotton state before the war, the crop was destined to make

a comeback, which it did during the late 1800s. With cotton so readily available, and the sharecropping system providing labor at a reasonable price, it was inevitable that a factory industry would crop up that made use of the South's most precious crop. Indeed, this came in the form of textile mills. Once again, cotton was helping to drive the economic engine in the state, and Atlanta was poised to take the lead in textile manufacturing.

With all these opportunities for work in Atlanta, it was no wonder that the population jumped by over twenty thousand people. In 1900, the population stood at ninety thousand. To top off this successful run, the state capital was moved from Milledgeville to Atlanta in 1868. It appeared that the phoenix was rising from the ashes Sherman left behind.

African American Migration

The growth of Atlanta led to the migration of many people to the area as they sought jobs and better lives. African Americans were no exception. The development and growth of centers of higher learning for African Americans—like Spelman College, Clark College, Atlanta University, Morehouse College and Morris Brown College—drew many young African Americans to the area, many of whom stayed after they finished their matriculation. Like the overall population of Atlanta, the number of black Atlantans grew tremendously. In 1860, there were fewer than two thousand African Americans in Atlanta; however, by the end of the century, that number had swelled to over thirty-five thousand.

Contributing to this growth, along with the venues of higher education mentioned already, were the lucrative business and social climates that existed in the city for black residents. Key among those were Sweet Auburn and the West End, both of which were thriving black neighborhoods and business districts. This climate produced such notable black entrepreneurs as Alonzo Herndon, who in 1905 established the Atlanta Life Insurance Company. By 1910, the company had over twenty-five thousand policyholders, no small accomplishment for an African American–held company considering the many obstacles that stood in its way just forty years after the close of the Civil War and the end to slavery in the South.

Time and Place

Atlanta was also fortunate to be the home of the early civil rights movement. As home to such notable institutions of higher learning as Atlanta University and Spelman College, it was inevitable that the Gate City would attract well-known African American academics. Notable among those was Dr. W.E.B. Du Bois, a professor of sociology at Atlanta University. The first black man to receive a PhD from Harvard University, Du Bois climbed the ladder of academic success and arrived in Atlanta in 1897. There, he taught alongside such people as Adrienne Herndon, the wife of Alonzo Herndon. Du Bois, who would go on to help found the National Association for the Advancement of Colored People (NAACP) and author the groundbreaking *The Souls of Black Folk*, was a moving force behind the Niagara Movement; edited the NAACP's magazine, *The Crises*; and became one of the leading voices in black America of the day. His counterpart—and in many instances, his opposite—Booker T. Washington, while not a resident of Atlanta, did give his famous "Atlanta Compromise" speech at the 1895 International Cotton Exhibition held in the city. The two towering figures would be integral to the debate over civil rights in the early 1900s and would become the most well-known African American figures in the nation in many respects.

THE 1906 ATLANTA RACE RIOT

As much as Atlanta had progressed in the years after the Civil War, and as much as it had become what many considered a haven for African Americans on the rise, it must be remembered that not everything had advanced. There were many people in Atlanta who held very backward views about race, and as some historians have noted, there were most definitely two Atlantas. That would be painfully obvious in 1906.

As the population of Atlanta began to grow, the municipal services offered by the city were stretched thin, and competition for jobs between black and white laborers was intense—a situation that made some whites in the city resent the growing number of African Americans who had come to live there. In addition, the emergence of a black upper class made many whites in the city uncomfortable. This came to a head during the 1906 gubernatorial election in Georgia. The candidates were Hoke

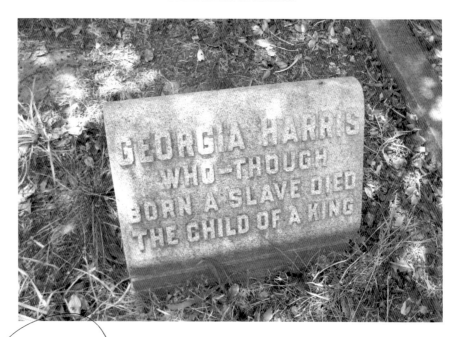

In Oakland Cemetery, even the graves were segregated, but a few African Americans, like Georgia Harris, were buried in the white section near their employers.

The inscription on the back of Georgia Harris's marker reflects the ideas of an era many would like to forget.

Smith, who had at one time been the publisher of the *Atlanta Journal*, and Clark Howell, an editor with the *Atlanta Constitution*. The papers have since been merged, but in the early twentieth century, they were separate entities vying for readership in Atlanta and beyond.

At that time in Georgia history, candidates for office often tried to "outdo" each other on issues such as white supremacy and keeping black Georgians from advancing politically and economically. This particular election was no exception. Both Smith and Howell debated back and forth, mainly through their respective news organizations, about how the other was not the right candidate for the job because he could not be trusted to help keep "blacks in their place." Smith argued that the only way to accomplish such a goal was to disenfranchise black voters. Howell, on the other hand, argued that the white Democratic primary and poll tax were sufficient methods to accomplish such ends. Howell further blasted Smith for being a bit of a lightweight when it came to advancing the idea of white supremacy in the state.

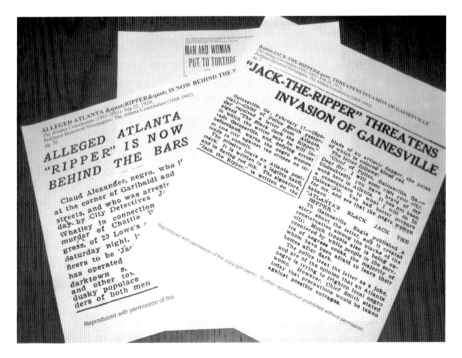

Articles from the *Atlanta Constitution* after 1911. This is evidence that many felt the Ripper was still at work, even years later.

To make matters worse, both newspapers were currently running articles about a series of alleged assaults on white women by black men in Atlanta. In addition to the *Journal* and *Constitution*, other papers, such as the *Atlanta Georgian* and *Atlanta News*, were filled with stories about black-on-white crime. These papers argued that the city was in danger if the blacks were not kept in their place and the saloons that black men frequented were not shut down. The papers added to the already growing racial tension in the city, a tension that no doubt had a lot to do with the advancements blacks had made socially, politically, educationally and economically since the close of the war. In September 1906, papers in Atlanta were carrying the news of four alleged attacks on white women that were supposedly perpetrated by black men in the city. It was the proverbial straw that broke the camel's back.

On Saturday, September 22, a mob of white men descended on downtown Atlanta. Enraged by the incendiary language and coverage in the press of alleged crimes, these men were bent on revenge, and violence was not too great a price to pay to exact it. City leaders, including Mayor James G. Woodward, tried to calm the mob, but to no avail. The men soon turned their anger on the central business district, attacking blacks on the streets and pulling them out of streetcars. Black-owned businesses were targeted, including the barbershop of Alonzo Herndon. Leaders in the black community called a meeting at Brownsville, an African American community near downtown Atlanta. Fearing that the meeting might be for the purposes of organizing an attack on the white community, the local police and state militia moved in and adjourned the meeting, making at least 250 arrests of black men. For the next few days, fighting continued, although somewhat diminished due to the fact that the state militia had already moved in to town and was patrolling the streets of the city. By Tuesday, September 25, the riots were over.

Although there is debate over the number of blacks killed during the four-day episode, it is generally estimated that between twenty-five and forty black citizens lost their lives. It is confirmed that there were only two white deaths. What is not debated is that the riots left Atlanta in bad shape in terms of race relations. Many black Atlantans who had made significant strides began to retreat from the public sphere. A number of black citizens and black leaders lost hope that their city might embrace

them and make them feel welcome as part of this New South. It was in this climate that the Ripper—or Rippers, for those who believe the crimes were perpetrated by more than one assailant—took to the streets to prey on the young black women who made their way through the streets of Atlanta to home and work.

2
THE RIPPER PHENOMENON

At a time when the African American population in Atlanta was already nervous due to the growing racial tension that had gripped the city and led to the 1906 riots, the stories of the atrocities committed by the infamous Jack the Ripper in London were still fresh on everyone's mind. When the rash of murders broke out in Atlanta at the turn of the century, it was quite unnerving, and this nervousness was amplified by the fact that the murders in Atlanta shared more than a few similarities with those in London. Much speculation resulted, and some even went as far as to say that ole Jack had hopped ship and headed for America, arrived in Savannah and then traveled to Atlanta to begin a new series of killings.

As preposterous as that sounds now, it was not so preposterous then. However, as the murders continued to happen, and eyewitnesses began to come forward—one being Emma Lou Sharpe, a near victim of the killer—it became apparent that the murderer was a tall, slender black man. While it would be possible for a black serial killer to have been in London in 1888, the conventional wisdom, as supported by evidence, suggested strongly that Jack the Ripper was a white man. The theory that he had made it to America was not all that preposterous, but the most notable suspect who did travel to America, Dr. Francis Tumblety, only came to light in 1993. So no one at the time of the Atlanta murders would have known about Dr. Tumblety and his voyage to the New World.

The Ripper Phenomenon

What is clear, though, is that the murders in Atlanta most definitely conjured up memories and images of the famous London atrocities. As evidence became clearer, the Atlanta fiend chose to take down his victims in much the same way as Jack in London had. Many of the victims of the Atlanta Ripper were found with their throats slashed like the victims of the London murderer. Other comparisons were not lost on the general public either. It was absolutely inevitable that the term "Ripper" would be applied to the character attacking and murdering young women on the streets of Atlanta.

Indeed, Jack the Ripper was a household name in the early 1900s. Newspapers around the world had been carrying stories about Jack since the events had started to unfold in 1888 in London. The *Atlanta Constitution* ran stories with headlines like "Jack the Ripper Sensation—A London Lodging-House Woman Claims That He Was Her Tenant," "Afraid of Jack the Ripper" and "Jack the Ripper's Limit: Growing Belief that Fifteen Victims Have Already Fallen Under His Knife." These were just a few of the headlines that sensationalized the crimes to the readers in Atlanta. Scarcely a person in the general public was not familiar with the murder spree going on across the Atlantic. There was mass hysteria in many places. Wherever there were a series of murders, or at least one that had the same characteristics as those in London, people—even law enforcement officers and journalists—were apt to call the murders the work of a local Ripper or to suggest that Jack had left London and was now in their city.

Yes, the people of Atlanta were familiar with the stories about Jack the Ripper and his work. In 1888, it was widely known that he had taken a knife and mutilated several prostitutes in the White Chapel area of London. The first victim was reported to be Mary Ann Nichols, who was murdered on August 31, 1888. Reports claimed that Jack waited until Nichols lifted her skirt (she was a prostitute), and while in the process of getting ready to deliver her services, he grabbed her around her throat and strangled her. After she was dead, he threw her lifeless body to the ground and, to add insult to injury, slit her throat. Atlantans most assuredly read about the follow-up murders of Annie Chapman on September 8, Elizabeth Stride and Catharine Eddowes on September 30 and Mary Jane Kelly on November 9. The media coverage was huge.

As some historians have noted, Jack the Ripper was not the world's first serial killer, but he was the first to have his ghoulish acts displayed on the front pages of major newspapers.

It was also noted how Jack's murders were all sexual in nature. Not only was he attacking women, but they were also prostitutes with seedy pasts. The way he mutilated his victim's bodies made it appear not only that Jack was mentally disturbed but also that there was something he was trying to say by murdering prostitutes in such a grisly way. Others speculated that he was a doctor, or that if he was not, perhaps he was a butcher or at least a man who had more than a nominal understanding of the human body. In addition to slitting the throats of his victims and cutting open their midsections, he took out certain organs. In fact, the fiend had not only mutilated the body of Catherine Eddowes but had also removed her kidney—cleanly, in fact. Later, a note was mailed to police officials, and included in the package was half a kidney. It was never ascertained if the kidney belonged to Eddowes, but the message was clear. If this was, indeed, the work of Jack the Ripper, and the letter and kidney were sent by him, he was not only dangerous and elusive but also deranged.

Jack also loved taunting the police—or at least someone did on his behalf. On September 25, 1888, the Central News Agency in London received a letter supposedly from the killer. In that letter, the writer, somewhat of a braggart, talked of how he enjoyed what he was doing and that he looked forward to killing again. He tantalized police by saying that they had no clue who he was and that on his next outing he planned to kill another victim—only this time, he vowed to cut off the victim's ear. When Eddowes was murdered, on the same night as Elizabeth Stride, the fiend did cut off her ear, which he left beside the corpse.

Jack was obviously playing a cruel game, not only with the poor denizens of London, but also with the very police force tasked with protecting them. As feelings of helplessness pervaded London and the police forces investigating the murders kept hitting dead ends, it appeared that the murders would never stop. But they did. After the death of Mary Kelly, Jack the Ripper's maniacal activities ceased almost as quickly as they had started. While many debate whether Jack was responsible for more murders after Mary Jane Kelly, most notable scholars on the subject agree that she was his last.

The Ripper Phenomenon

After the murders, it was not long before much interest developed in these crimes, and a number of sleuths, both amateur and professional, started trying to solve them. Between 1889 and 1909, there were nine books available about the killing spree of London's Jack. Newspapers, both in America and Europe, began to use the term "Ripper" quite freely when referring to murders involving young women and slit throats. So it was no wonder that when the murders began in Atlanta, newspapermen, law enforcement officials and citizens alike would, on more than one occasion, suggest that the Gate City had its own Jack the Ripper.

3
1911
The Year of the Atlanta Ripper

As 1909 rolled in, Atlanta was trying to regroup from the riots that had taken hold of the city just three years earlier. The city continued its economic growth, and in the black community, even amidst the racial tension that had long pervaded the city, black business owners and entrepreneurs continued to make strides. However, the memories of the riots of 1906 were still lingering.

At the opening of 1909, Hoke Smith was governor, but later that year, Joseph Mackey Brown, the son of Civil War governor Joseph E. Brown, took the reins of leadership in the statehouse. In the city, Robert Maddox was sworn in as mayor in January, serving in that capacity until Courtland S. Winn took office two years later, in 1911. Unfortunately, not long after the spring season blossomed in the Gate City, the first of many murders took place.

On April 5, 1909, Della Reid was found in a trash pile near 71 Rankin Street, according to an article that ran later, during the height of the Atlanta Ripper murders, in the *Atlanta Constitution*. While it is not clear if this murder was committed by the man who would become known as the Atlanta Ripper, it is clear that the black citizens of Atlanta were unnerved by the murder and considered it part of a rash of attacks on black women that had the city's black neighborhoods gripped with fear.

To make matters worse, on September 7, 1909, an unidentified woman was found in Peachtree Creek. As 1910 rolled in, it seemed that black

1911

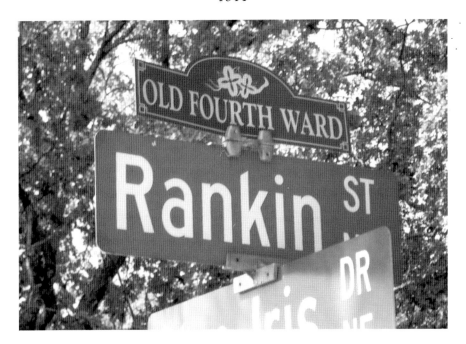

Rankin Street. Della Reid was found in a trash pile near this area on April 5, 1909.

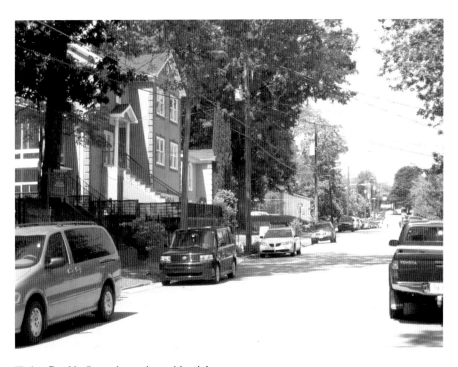

Today, Rankin Street is a quiet residential area.

women were being murdered on the streets of Atlanta at a rate of one per month. On March 5, Estella Baldwin was found dead. The cause of her death was listed as a concussion of the brain, and an address of 735 North Jackson Street was given. While it is not clear if the address was her home address or the area nearest to where she was found, it seems clear from the "concussion of the brain" notation that she was struck in the head with blunt force. Exactly one month later, Georgia Brown of 167 Martin Street died of a gunshot wound. The next day, Mattie Smith of 141½ Peters Street also died of a gunshot wound. A month after the death of Ms. Smith, Lavinia Ostin was also found dead of a gunshot wound; however, the location was not given. Later that May, on the twenty-third, Sarah Dukes of 119 Curran Street died of a gunshot wound, as did Francis Lampkin of 407 Foundry Street. Near Labor Day, an Eliza Griggs of 28 Dover Street was found dead of a gunshot wound. And to round out the year, on October 6, Maggie Brooks of East Ellis Street was killed on Hill Street.

It is not certain by the newspaper coverage of these murders if they were all attributed to an unnamed assailant; however, as is evident in later coverage during 1911, they do indeed heighten the fear and apprehension in Atlanta and make the black citizens, particularly women, afraid for their safety out of doors. These murders also alarmed the leadership in the black community in Atlanta. In July 1911, a group of black pastors included these names on a list of women slaughtered in Atlanta that was presented as part of a petition to the governor and the mayor to help stop these acts of violence and exhaust whatever means were necessary to apprehend the perpetrator. The petition also boldly stated that those forwarding said request had no knowledge of any convictions for these murders. From that, it is obvious that by the time of the petition, all of these deaths were considered murders and that the petitioners more or less felt that they were the work of the man who was later tagged the Atlanta Ripper.

As 1910 rolled into 1911, things got worse. The year had barely begun before a grisly murder took place on Gardner Street. According to the *Atlanta Constitution* on January 23, 1911, Rosa Trice, a thirty-five-year-old woman living in the Pittsburg community, was found dead on the morning of January 22. She was found just seventy-five yards from her

1911

Mattie Smith was killed in the vicinity of Peters Street on April 6, 1910.

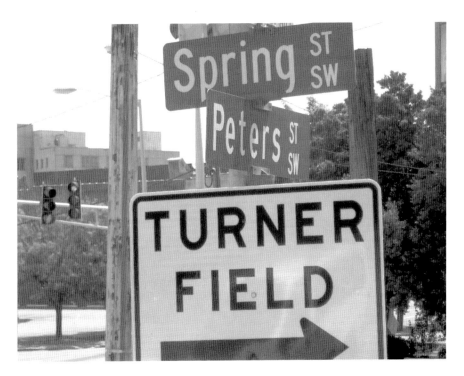

This sign indicates the progress since the "Ripper" murders. Turner Field, home of the Atlanta Braves, is nearby.

Peters Street. This area has been hard hit by the economic downturn of the last few decades in Atlanta.

home, and the description of the condition of the corpse sounded like something from a horror novel. The article stated:

> *The murder had evidently been committed some time during the night, and she had lain in the street for some hours after death. Her body had been dragged for some distance by her assailant. No weapon was left to show the manner of the crime. The left side of her head was crushed with some blunt instrument, she had received a stab in the jaw and her throat was cut.*

The article went on to report that her husband, John Trice, had been arrested at the Trice home shortly after his wife's body was found in that condition. Trice was incarcerated, and in the meantime, the coroner conducted a thorough investigation; however, no evidence could be found that John Trice was in any way involved in the murder, and he was released.

Domestic Violence Shocks Atlanta: A Rumor Draws a Crowd

Less than two weeks later, perhaps one of the strangest murders in Atlanta took place on Spencer Street. While the man accused of this crime was the husband of the victim, and it was not the work of the Atlanta Ripper, the event did nothing to allay fears and tension growing in the black community.

On February 3, Lucinda McNeal was brutally assaulted and murdered by her husband, Charles McNeal. According to an article in the *Atlanta Constitution* the next day, "When the officers reached 92 Spencer Street they found a negro woman dead from knife wounds inflicted by her husband, who had already been arrested by Mounted Officer C.H. Brannen." The article also reported that a large group of people congregated at the home of the McNeals to see firsthand the grisly work of the husband—namely Mrs. McNeal's head dangling by a small strip of flesh.

Apparently, Charles McNeal had returned to the Spencer Street home at about 3:30 p.m. full of drink. He then attacked his wife with a razor. He slashed her head, breaking his razor at the joint from the sheer force of the blows thrust upon her. At that time, not satisfied with his work and refusing to allow the useless weapon to slow him down, he removed a pocketknife, which he used to finish the grisly work. Ironically, the pocketknife broke as well. Once the murder was done, McNeal bolted from the house but was pursued by three other African Americans in the vicinity who had witnessed the dastardly deed. Eventually, McNeal was arrested on Chestnut Street by Officer Brannen.

What was most unusual about the incident was that, through all of this uproar, rumor spread that an Atlanta police officer, J.A. Hollis, had been shot and killed on Spencer Street during the episode. This news brought a mob of almost one thousand people to the area, a sight that must have been quite unnerving in the Spencer Street community given the events of five years earlier, when huge mobs of white citizens took to the streets during the 1906 race riots. It appears that someone had called in Officer Hollis's death to the police dispatch office at about 4:20 p.m. Swarms of officers on foot, bicycle, automobile and horseback flocked to the area to confirm the reports. Panic swept through the area, only to be quelled

Spencer Street. Lucinda McNeal was killed in this neighborhood by her husband on February 3, 1911.

There are many vacant run-down homes in the Spencer Street area today.

1911

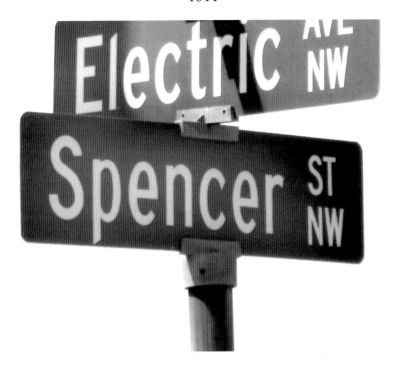

The street sign that marks the area where Lucinda McNeal died. This street is across from the Georgia Dome, home of the Atlanta Falcons.

when Officer Hollis himself returned to the station house after his patrol was done for the day. No one knew for sure how the misinformation came about. What could be reported was that the initial call came in from a woman who said that there was a murder in the area, only to be followed by another call reporting that Hollis was dead and that his body was lying outside across the sidewalk. Hollis confirmed that he had indeed gone to the area to investigate the killing of Lucinda McNeal, but he was unsure why someone named him as the victim.

Before the black community could rebound from this heinous act perpetrated on a wife by her drunkard husband, it appeared that the Atlanta Ripper had found his next victim. On February 19, another woman was found in Grant Park. Although the victim was never identified, and not very many clues surfaced from the murder, later on police felt certain that she had been a victim of the Ripper. Her throat had been slashed and her head bashed in very much like Rosa Trice's back in January. The discovery of this body was the second gruesome murder in

the month of February in the black community. People began to notice, and young black women were becoming alarmed by the possibility of a serial killer who was preying on their age and gender group on the streets of the capital.

As spring blossomed in Atlanta, the Ripper seemed to stand down, for no known murders connected with this spree were reported in March or April. However, the killer did not rest on his laurels for long. On May 8, he struck again, but this time his weapon of choice was not a blade but the barrel of a gun. The victim was Rosa Rivers, who lived at 122 Randolph Street. The *Atlanta Constitution* reported her death on May 8, 1911. The article stated:

> Shot from a distance by an unknown negro man, Rosa Rivers, a negress of 122 Randolph Street, is at Grady hospital, where it is said she is fatally wounded. The shooting occurred at the corner of Auburn avenue and Howell street last night at about 10:30 o'clock. The woman was in company with her sister and another negro woman when a man approached them and fired. He escaped.

While the paper indeed covered the incident, what has just been quoted is the *entire* article. The black community was already on edge and had long been taking these events seriously. In the white community, which controlled the mainstream press in the city and state, the murders were not seen as anything out of the ordinary, and at that point there was no talk of a serial killer and certainly no mention of the word "Ripper." The issue of race was not only a factor in where blacks could live, work, shop and even be buried, but it also played a role in how crimes involving them were reported. These murders were evidence of such a double standard.

The murders continued in May of that year, and likewise, the white press continued giving them scant attention. On May 29, the *Atlanta Constitution* reported the murder of Belle Walker. The report read:

> Her throat cut with a jagged edge, Belle Walker, a negro cook, was found dead yesterday morning about 25 yards from her home, 122 Garibaldi street. There is not clew [sic] to the murderer, according to the inquest

1911

Rosa Rivers was shot near the Randolph Street area on May 8, 1911.

The modern street sign for Randolph Street indicates its location inside the historic Fourth Ward.

The intersection at Randolph Street. Rosa Rivers died near here on May 8, 1911.

Randolph Street today is a quiet residential area.

1911

held by Coroner Donehoo. The woman cooked at 191 Cooper street, and left there Saturday night for her home. Her sister started a search for her Sunday morning when her bed was found empty, and the murdered body was discovered in an old field near the house.

No details were reported about the way she died or the condition of the body when it was discovered. The Ripper had claimed yet another victim.

On June 15, the killer struck again; this time, his victim was Addie Watts of 30 Selman Street. Her body was found near the Southern Railway line, her head bashed in with a coupling pin and her throat slashed. After the murder of Watts, at least one white-owned newspaper in Atlanta began calling the murders what they were: serial killings. An article ran in the *Atlanta Journal* proclaiming that the deaths might be the work of what they called a "Black Butcher." It was also in this story that the editors started making a striking comparison to the works of Jack the Ripper. For the first time, the name "Atlanta Ripper" was used in

Garibaldi Street. Belle Walker was killed here on May 29, 1911.

This modern street sign identifies Garibaldi Street, the site where Belle Walker's body was found by her sister the day after her murder.

Selman Street. Addie Watts died in this area on June 15, 1911.

This street sign indicates that there is still life on Selman Street.

Selman Street today is a quiet residential neighborhood.

connection with the crimes. Over at the *Atlanta Constitution,* the coverage was not quite the same. That paper still reported the death of Watts as it had the other murders—as isolated incidents with no evidence of a connection and certainly no mention of a serial killer.

Right on the heels of the murder of Addie Watts came the death of Lizzie Watkins of West Oakland Street. Police found her body dumped in brush near White and Lawton Streets on June 27. At this point, the *Atlanta Journal* gave front-page attention to the city's newest arch criminal. The editors went so far as to begin examining the similarities between the murders. At least the *Journal* understood the gravity of the situation. Not so for the *Atlanta Constitution*—it had yet to make that leap. When the police reported the death of Lizzie Watkins, the paper responded with the same sort of coverage as the others, only this time it managed to add its own spin, citing that it was certain the death was the result of alcohol and drugs.

Emma Lou Sharp Comes Face to Face with the Atlanta Ripper and Lives to Tell About It

With the *Journal* picking up the pace and clamoring about Atlanta's version of Jack the Ripper, the *Atlanta Constitution* could not help but see that there was definitely something to all this talk about a serial killer. After the Ripper killed his next victim, the debate was over, and the press moved ahead with its coverage of the murders.

The next murder got quite a write-up in the *Constitution*. Considering the details of the event, it is no surprise that it did. On July 2, the Ripper struck again, and this time he left an eyewitness who could give an account of what happened, as well as provide some details about the fiend's appearance. It was in the article published in the *Constitution* that the editors of that paper began considering the similarities between the Atlanta happenings and the murders committed by Jack the Ripper in London. The victim this time was Lena Sharp.

Sharp's story actually focuses more on the actions of Lena's daughter, for it was Emma Lou Sharp who was stabbed by the Ripper but lived to tell about it and give a partial identification. On the night of the second,

1911

Lena left her home at 24 Hanover Street around dusk. Her intent was to visit the local market. Emma Lou decided to stay home, where she awaited her mother's return. When her mother did not return in a reasonable amount of time, Emma Lou decided to go out looking for her—a decision that was near fatal. Reaching the market, Emma Lou inquired as to the whereabouts of her mother. Having been assured by the proprietors that her mother had never visited the market that night, Emma Lou began a search.

It was at this point that she almost met her demise, for on the dark streets near her home she encountered a tall, dark, broad-shouldered man wearing a broad-brimmed black hat. The stranger spoke to her, asking her how she felt that particular evening. Images of Addie Watts came to her mind, and Emma Lou immediately was frightened. Her next thought was to get away as quickly as possible. Answering that she was doing quite well, she began to walk ahead, only to have her path blocked by the stranger. Again he spoke, this time saying, "Don't be 'fraid. I never hurt girls like you." Without giving her the opportunity to respond, the stranger pulled out a knife and plunged it deep into her back. According to Emma Lou, the assailant did not stay around to see if his knife had done its intended work. He quickly fled on foot and disappeared into the night. As the knife pierced her back, Emma Lou let out a bloodcurdling scream, drawing a large crowd of people who helped her to her home. However, the crowd arrived too late to catch a glimpse of the Ripper.

Shortly thereafter, a party of several men did what Emma Lou was unable to do and found her mother, but she wasn't alive. The article in the *Constitution* reported:

> *A party of negro men walking in the vicinity of the Seaboard railroad tracks near Hanover street shortly afterwards stumbled over the prostrate form of Lena Sharp. A light revealed a huge gash in her throat and her head lay in a pool of blood. The body was removed and an inquest will be held today.*

Immediately, detectives deduced that the same man who had attacked Emma Lou Sharp had killed her mother. No reasoning for this conclusion is mentioned in the article, however. It was further suggested in the same

article that the murderer on that night was also the man who took the lives of Addie Watts and the other women murdered in the preceding months. As the title of the article points out, the editors of the *Atlanta Constitution* believed that they had a gruesome serial killer on their hands and that Atlantans were not safe as long as he ran the streets without arrest. This assertion was not far off base at all, judging from the condition in which Lena Sharp was found, for the throat slashing she received had almost resulted in decapitation.

July was a busy month for reporting on the Ripper. On Independence Day, the *Constitution* reported that a reward was being offered for the capture of the black killer. The article mentioned that

> *in an attempt to apprehend the slayer of Lena Sharp, a mulatto negress, who was killed in the vicinity of Hanover street Saturday night, L.L. Lee, a prominent negro undertaker had offered a reward of $25.00 for the apprehension of the murderer, who is also thought to have killed six other negro women within the past month.*

From this article, it was apparent that the community was now stepping up its efforts to help police bring down this clandestine attacker. Not only did Mr. Lee offer up his own money to help entice volunteers to assist police, but he also made a plea for other members of the black business community to open their wallets and make the fund more tantalizing. With the description given by Lena Sharp, police and leaders in the black community felt that the Ripper might be caught within days. While this was a bit off the mark, it certainly illustrated that the community was serious about stopping these attacks on the young black women of Atlanta.

Henry Hugh Proctor and Atlanta's Black Elite Take Up the Cause

It was just a few days before the notable Reverend Henry Hugh Proctor, pastor of the First Congregational Church in Atlanta, took up the issue as well. On July 9, a meeting was held at the church where Proctor and

other leaders in the black community condemned the murder spree and called on every African American in Atlanta to use every resource at his or her disposal to find the predator. The meeting also produced a resolution to call on black Atlanta to cooperate fully with the police force as it sought to bring in the culprit and another one requesting that the police hire black detectives to assist in this effort. This last request, which would seem strange if made in the twenty-first century, was quite logical in 1911. The city's segregation and racial tension were still present, a fact that had not escaped Reverend Proctor and others leading this charge. They knew that a black detective might be seen as less invasive in the black community and perhaps would lead to more cooperation from the members of the black community. In addition, Proctor and the others felt that the presence of a black detective would help parlay the message that black Atlanta was doing everything in its power to stop the mass murder of their own.

If there was indeed a person to lead the effort in the black community, it was Reverend Henry Hugh Proctor. A native of Tennessee, Proctor was a graduate of Fisk University with a Bachelor of Arts degree, as well as Yale University, where he graduated with a bachelor of divinity degree in 1894. He came to Atlanta that year and was ordained as the pastor of the First Congregational Church, a church that had a biracial mission. Within a few years, Proctor had made a name for himself in Atlanta as a crusader for decency, racial harmony and an end to crime. In the process, black Atlanta noticed, Atlanta University awarded him an honorary doctor of divinity degree. Furthermore, Proctor was the man on whom the white leadership in Atlanta called to establish talks with the leadership in the black community to bring an end to the race riots in 1906, as well as discuss ways for both races to live peacefully together in the city. Proctor called together fifteen hundred members of the black community, the movers and shakers, to be part of the Colored Cooperative Civic League, a parallel organization to Charles Hopkins's Atlanta Civic League. The leadership of the two groups met on September 25, 1906, at the Fulton County Courthouse. This meeting has long been lauded as a gold standard for interracial cooperation in the first half of the 1900s. Proctor's involvement did not go unnoticed.

As the pastor of his church, he built the congregation up to over one thousand members by the time he stepped down as pastor. Breaking ground for a new facility in 1908, the guest speaker at the official ceremony was Booker T. Washington. Upon its completion, Reverend Proctor entertained such notable guests as Presidents Theodore Roosevelt and William Howard Taft. The church and its leadership even earned praise from the famous Reverend Washington Gladden, a white minister from the North who had been instrumental in the Social Gospel Movement. With these accolades and this list of achievements, it was no surprise when Reverend Proctor stepped up to the podium and put the power of his words and leadership to work in helping stop the next thing to bring death and destruction to his beloved black community in Atlanta: the inhuman murderer whose mission of killing the young woman of black Atlanta was taking its toll.

Reign of Crime Shakes the Gate City: The Ripper Continues to Claim Victims

Just four days after the city celebrated Independence Day, the Ripper was back on the streets prowling for another victim. Perhaps he was angry that Emma Lou Sharp managed to get away and provide the first ever identification of him. However, his luck would be no better in his next attempt. On Saturday, July 8, Mary Yeldell, a cook for W.M. Selcer, left the Selcer home on Fourth Street. While walking home, she was distracted by the sound of a whistle that came from down a dark alley. Stopping to see if someone was whistling for her, she soon found she was being approached by a tall, well-built black man. He was approaching her quickly and quietly. She screamed and started back toward the Selcer home, where she sought refuge.

Mr. Selcer headed out on foot, revolver in hand, to the alley where the man had approached Yeldell. Upon arrival, Selcer was shocked to see a man still standing in the alleyway. Selcer called out to the man to put up his hands, but the stranger ran away down the alley and out of sight. Selcer returned home and phoned the police, who came on motorcycles, but their search turned up nothing. The Ripper was zero for two in July, but he would not let that stop him.

Just a few days after his attempt on the life of Mary Yeldell, the Ripper claimed another victim. This victim was said to be the Ripper's eighth. The *Constitution*'s headline proclaimed the city's frustration as it reported the July 10 death of Sadie Holley: "Reign of Crime Grips Atlanta; Police Defied: Homes Are Robbed, Negro Women Slain, and No Arrests Are Made." The murder of Lucinda McNeal had made page-one headlines; however, her murder was not at the hands of the Ripper, and the story had been coupled with the rumor of the death of a white policeman, J.A. Hollis. This was the first Ripper victim to appear on page one of the *Atlanta Constitution*.

The paper reported that Sadie Holley was found on Atlanta Avenue. In addition to the murders, the crime wave affecting the white community was discussed, namely gangs of thieves robbing homes in the white community. The paper, now with a worried tone, proclaimed, "Neither 'Jack the Ripper' on the one hand, nor the gang of thieves on the other has let up for one week in their terrorizing crimes. In fact, the deeds grow bolder and bolder with each successful evasion from capture at the hands of police and detective departments of the city." In showing the growing frustration toward local law enforcement agencies, which seemed powerless to help, the paper reported:

> *The police department has nothing to say in explanation of its inability thus far to cope with the situation, further than the simple declaration that it is doing its best. In the meantime the negroes, naturally panic-stricken that eight women of their race have been murdered in cold blood within as many weeks, are holding mass meetings, and are appealing to the governor, the mayor, and to the law-loving citizens to help them in capturing the guilty party or parties, and to put a stop to this reign of bloody crime.*

The details of the murder of Sadie Holley aroused even more fear in the black community. Her body was found in much the same state as the other victims, her throat slashed and her head bashed with a large stone. A laborer, Will Broglin, discovered her body while on his way to work. He said that he noticed signs of a scuffle in the freshly graded soft dirt on his route to work. He followed the traces and came upon the body. The stone that was used to kill Holley turned up in a nearby field. Police

followed the prints and the trail left in the area by the killer, but it gave out not far from the corpse. Unlike the other murders, the assailant removed Holley's shoes and took them. They were never found.

The murder of Sadie Holley must have shaken up the folks at the *Atlanta Constitution*, as the coverage of her death also brought on a review of the past year's events. The paper reported, "Looking back over the murders, it is seen that they have not started recently, but only in the last two months have they gained such frequency and regularity as to attract universal notice." The story went on to say:

> *On February 19 an unknown woman was found near Grant Park with her head crushed and her throat cut. On January 22, Rosa Trice had been killed near Gardner Street and the Southern railway in the same manner. From June 19 on there has been one murder weekly, starting with Addie Watts, who was found near the railroad, her head mashed with a coupling pin and her throat cut.*

The succeeding sentences in the report went on to list all of the victims found up to Sadie Holley. The same report also mentioned that the black pastors in Atlanta were calling on the mayor and governor of Georgia to offer a reward for the capture of the murderer.

The Business Community Calls for an End to the Ripper's Reign

As the body count continued to grow, the business and civic leaders of the city grew more and more concerned. On July 13, the Atlanta Chamber of Commerce passed a resolution calling on Mayor Winn and Governor Hoke Smith to offer a monetary reward for the capture of the murderer. The resolution, introduced by John E. Murphy, read:

> *Whereas, during the past few weeks there has been at Atlanta an outbreak of crime which has cost the lives of a number of honest and hard-working colored people and these crimes, most of them with helpless women for their victims, are of a particularly diabolical nature, and*

1911

> *Whereas, it is the first duty of any government to protect the lives of its citizens, especially the weak and helpless, and the colored people of this community, including thousands of hard-working and honest men and women, whose labor contributes largely to the productive industry of the community, although they have little voice in control of public affairs or the administration of government. Therefore, be it*
>
> *Resolved by the directors of the Atlanta Chamber of Commerce, That it is incumbent upon those in control of the administration of government to see that members of this dependent race are fully protected in their life, liberty and property and that the community is rid of those criminals who have of late caused a reign of terror among our colored citizens.*
>
> *Resolved further, That we call upon the governor and the mayor and general council to take such action as will result in adequate police protection to everyone in this community, particularly those in outlying settlements where crime had been rampant of late, and that they issue rewards for the arrest with evidence to convict the perpetrators of these diabolical crimes.*
>
> *Resolved further, That a committee be appointed to wait on the governor and the mayor and present this matter to them in person.*

From this resolution, it is easy to see that the Atlanta Chamber and its membership felt that the city was in peril if this fiend was not stopped. Also interesting to note is the kind tone that the resolution takes in referring to those who had been slaughtered by the fiend, particularly the phrasing "honest and hard-working colored people." The term "colored" was considered the polite way of referring to African Americans of the day. One thing does stand out in this resolution, however, and that is the mention of the impact that the murderer was having on the "honest men and women, whose labor contributes largely to the productive industry of the community." As might be suspected, some were pleased that the Atlanta Chamber of Commerce was taking up the issue and staking out such a bold position on behalf of the black community. Others, however, felt that the only reason it was doing so was because, if these murders did not cease, they would have a negative impact on the business climate of the city. This discussion is further evidence that the racial tensions were far from being resolved in the Gate City.

The Police Haul in Two Suspects: Was the Ripper in Custody?

Soon after the death of Sadie Holley, police hauled in a man they thought was the killer: Henry Huff, a twenty-seven-year-old laborer who lived on Brotherton Street near downtown. There was much evidence suggesting that Huff was the killer. Witnesses could put Huff with Sadie Holley on the night she was killed. On top of this, police reported that when they arrested Huff, he was wearing bloody clothes and had scratches on his arms, perhaps from fingernails. Was it possible that Sadie Holley fought back against her attacker? In addition to the scratch wounds on his arms, Huff's head was gashed, an injury he claimed to have gotten in a poolroom fight, to which he also attributed the amount of blood on his trousers.

The second suspect brought in by police was Todd Henderson, a thirty-five-year-old African American who was identified by Emma Lou Sharp as the man who accosted her. According to the *Atlanta Constitution*:

Brotherton Street. Henry Huff, who was accused of the murder of Sadie Holley, lived in a house on this street.

> *The case against Henderson seems very strong. He has been wanted since the first discovery of the murder, but had successfully eluded the officers in spite of the efforts to locate him until yesterday afternoon, when he was found in a Decatur street near a beer saloon by Detective George Bullard, who is working on the case with Detectives Black and Harper.*

However, as the article continues, it becomes clear to see that the identification given by Emma Lou Sharp was not as solid as it could have been. When detectives brought Henderson in front of Emma Lou and asked her if that was the man who attacked her, her response was: "To the best of my knowledge." Some were not satisfied with that response, so they asked Henderson to say to her, "How you been gittin' long?" When Sharp heard Henderson speak, she pulled back in horror, suggesting that this was the voice she had heard speaking to her out of the darkness on the night she was approached and attacked by the perpetrator. While this seemed to build an even stronger case against Henderson, the case got an even bigger boost when a clerk in a grocery store near 24 Hanover Street, near the murder scene, said that she saw Henderson in the vicinity on the night of the murder.

Another witness came forward, this time from Cone's drugstore near the intersection of Pryor and Decatur Streets, concerning Sadie Holley. According to the clerk's statements, which were also verified by Dr. Cone, the proprietor, Henderson accompanied Holley into the grocery store at about 11:00 p.m. that night. Police considered this strong evidence, as they now had the identification provided by Emma Lou Sharp and an eyewitness or two who could tie Henderson to Sadie Holley.

As Todd Henderson remained in custody, the police began pushing harder and harder to build a case against him. It was reported that his foot matched the heel print that was found in the dirt near where Sadie Holley was found. Henderson maintained his innocence the whole time. He asserted that the reason he was in the area where Holley died, and the reason that so many people recognized him, was he lived in the area; this was a statement the police felt was a lie. Detective Bullard was reported to have said to him, "If that was the case, Todd, I would have gotten you long ago." Henderson continued to maintain his innocence, even

suggesting that if he were going to kill anyone, his wife would have been his first victim a long time ago.

In fact, Henderson did live near the area where Holley was found. The papers reported that he lived near the West Point belt line where it crossed Hill Street. This area is also not far from Grant Park, the scene of another grisly murder where an unidentified body was found. His home was also near the area of town where two other Ripper victims were found. While this is not solid evidence against him, it does look suspicious, as many of the murders seemed to be happening in the vicinity of his home. Henderson's statement about his wife was not entirely off the mark, either, as he had been in and out of trouble prior to his arrest, mainly because he had tried to cut his wife. He was even known to follow her around town and spy on her; on one occasion, he spied on her as she visited a friend at police headquarters. Henderson might or might not have been the Ripper, but it was more than certain that he was a man with a temper. Still, he was fortunate in that he had steady work. He worked for several people in the area sodding grass and doing odd jobs for more-than-decent wages.

As these suspects were in custody, the hysteria created by the murders took its toll on the black community in Atlanta, particularly young women who worked as servants for other families in the area. On the outskirts of the city, six women were frightened by a man they thought might be the Ripper. The man, they said, appeared out of nowhere in a field they were passing on their way home. All of these women worked as servants and were young African Americans—a demographic group of which the Ripper seemed to be quite fond. As they saw the man, they screamed and fled from the area, shrieking so loud that their yells could be heard for quite some distance. When a Mrs. McAdams of DeKalb Avenue called in the report, police were quickly dispatched by motorcycle. Shortly afterward, the women were interviewed by police and reported that the man they saw was tall and black, wore a black hat and had on a shirt with long sleeves. It was apparent that the women were thinking of all the murders taking place in the city, and they all felt that they were looking directly at the Atlanta Ripper himself. Given the descriptions circulating in the newspapers, it was not hard to imagine why they felt that way. It must also be remembered that a lot of the information and press reports

about Henderson and Huff being in captivity had yet to be revealed to the public at the time the women spotted this dark, lurking figure.

Police searched the area and found nothing. The press surmised that the whole incident might have been a joke, but the fear the prankster inspired in the six women was proof positive that young, black women were greatly unnerved by what was happening. If these murders were not solved and the crime spree brought to a screeching halt, perhaps no young black woman would be brave enough to venture out into the streets of Atlanta at night—or in broad daylight—for much longer.

THE COMMUNITY CONTINUES TO CALL ON GOVERNOR HOKE SMITH AND MAYOR COURTLAND WINN FOR HELP

It wasn't just the black community that felt a sense of urgency. Many citizens around Atlanta felt that the state and local officials should do more to bring the murders to a grinding halt. Just prior to the arrests of suspects Henderson and Huff, the community was in the process of sending even more petitions to Governor Hoke Smith and Atlanta mayor Courtland Winn. As mentioned already, the Atlanta Chamber of Commerce drew up a petition asking that a reward be offered and that local law enforcement make haste in bringing in all the bandits involved in the murders and robberies gripping the city. The petition produced and circulated by Reverend Henry Hugh Proctor and other black ministers of Atlanta had picked up several notable endorsements from the white community. Included among those were Asa G. Candler, Captain J.W. English and Clark Howell.

Asa Griggs Candler would eventually go on to become mayor of Atlanta. But before his stint in politics, he proved himself as a fine and able businessman in the city. Having been a druggist at one point early in his career, in 1888, Candler put together a plan and partnership to buy out the holdings of John Pemberton, the inventor of Coca-Cola. It was not long after that when he bought out his business partners and became the sole owner of the world's most famous drink. In 1906, he opened the doors to his famous Atlanta landmark, the Candler building—a

seventeen-story skyscraper at the intersection of Peachtree and Houston Streets. The building was the tallest in Atlanta.

Captain James Warren English, a man who had served at that rank in the Confederate States Army during the War Between the States, built his fortune in Atlanta through cotton, railroads, bricks and banking. Like Candler, he also contributed to the skyline of Atlanta with his famous Fourth National Bank Building, which he built in 1905 at the corner of Peachtree and Marietta Streets. Captain English had quite a resume in Atlanta politics and civic affairs. He was a member of the committee that helped bring the capital of the state to the Gate City. He served the city as its mayor after being elected in 1881. As late as 1906, he was still serving the citizens of Atlanta as the chief of the city's police commission.

Clark Howell, also of note in the city's business and political life, was the editor of the *Atlanta Constitution* and a Democratic candidate for governor in 1906. Although he ran a spirited campaign and garnered quite a bit of support throughout the state, he eventually lost his bid to Hoke Smith, the man to whom the petition he signed was addressed.

Before the petition made its way to the desk of Governor Smith, General Clifford I. Anderson, chairman of the Fulton County Commission, signed it. With his signature, the petition had the support of not only the local business community but also the local government. Governor Smith cordially received those forwarding the petition in his office, and he agreed to take the matter under serious consideration.

Also alarmed by the events unfolding in his city, Atlanta mayor Courtland Winn held a meeting where he requested the presence of Carlos Mason, chairman of the police board; Henry Jennings, chief of police; and Newport Lanford, chief of detectives. Voicing his frustration, Mayor Winn commented:

> *Just why the police have not been able to hold down the unusual number of crimes reported in the city in the past few weeks, why the detectives have not been able to apprehend the criminals and why the police are unable to cope with the situation is more than I can understand, but these things I am going to find out if there is any possible way.*

After giving these comments, Chief Jennings, Chief Lanford and Chairman Mason went into a closed meeting with the mayor. Emerging from the meeting, Chief Jennings reported that the mayor merely wanted an update on what the police were doing to stop both the ring of thieves rampaging through the city and the murders. Chief Jennings said that the report was made, and the meeting adjourned.

Mayor Winn also reported that right before his meeting with police officials, leaders from the black community came to him personally asking him to offer a reward for the capture of the Ripper. Those speaking to him on behalf of the black community were Reverend J.A. Rush, pastor of the Central Avenue Colored Methodist Church, and Mr. Henry Rucker, former collector for the Internal Revenue Service in Atlanta. Mayor Winn reported that he was glad to offer any assistance he could to bring in the fiend; however, it was against city law for him to offer a reward. He said that he would ask the city council to appropriate money for such a reward. Once the delegation of black leaders left Mayor Winn's office, they visited Governor Smith and the officials at the county commission. All parties voiced their eagerness to assist in any way possible.

It is important to note that the arrests of Henderson and Huff were being made at this time, and some, but not all, of the frustration and concern voiced by local officials would be tempered by their booking. However, before the city and its leaders could get too comfortable in their capture, Mayor Winn continued to browbeat local police. The press reported that the mayor believed that the police could do a good deal more and be more efficient in their pursuit of the city's criminals, particularly the Ripper. He also commended the leaders of the black community for being eager and insisting on the protection of their people and the well being of the city. He commented that the visit by Reverend Rush and Mr. Rucker was not their first attempt and that a letter had been sent by local black leaders to his office in June, a month prior to the visit, asking for his assistance in the matter.

While Henderson and Huff were both in custody, many moved forward as if the Ripper were still at large. A few days after the murder of Sadie Holley and the pickup of the two suspects, Atlanta police assigned eight undercover police officers to night duty in the city. In addition, city police chief Henry Jennings offered reasons that his force could not

bring the crime wave to a halt. He professed, "The police department is handicapped, seriously so, by its small size, but even if we had more men, we could not stop crime."

At long last, there was light at the end of the tunnel in terms of the governor's cooperation with the efforts to establish a big monetary reward. On July 14, the papers reported the Governor Smith had proclaimed that a $250 reward was now being offered for the capture of Atlanta's Jack the Ripper. Joining in the effort, Mayor Courtland gave his word that he would indeed approach the Atlanta City Council for a monetary reward. It was said that Governor Smith and Mayor Courtland reached their decision after representatives from the Atlanta Chamber of Commerce visited with them about this issue. With these leaders of the white business community coming down in favor of a reward and heightened efforts, the governor and mayor could not refuse.

It can only be imagined how the leaders of the black community must have felt, realizing that the chamber of commerce's pleas did more than theirs to bring about action. The black community had a long way to go in terms of clout with local and state officials. Nevertheless, many African Americans showed gratitude and deep appreciation to both Governor Smith and Mayor Winn, as well as to the leaders of the chamber, for their continued efforts in assisting with the manhunt.

The Case Against Huff and Henderson Grows, But Doubt Remains

As police continued to investigate Henderson and Huff, they came upon more evidence, although circumstantial, that they felt pointed to these men as being responsible for some of the murders, most particularly Lena Sharp and Sadie Holley. It was discovered that Henderson was seen with Holley in a lodging house on Decatur Street. On Monday night, the same night as her murder, Henderson came to the same place looking for her. It was also discovered that there were witnesses who saw Holley with Henderson as late as 11:10 p.m. on Monday. Detectives in charge of questioning Henderson also reported that he had contradicted himself several times. To prove that Henderson had been seen with Sadie

Holley on the previous Saturday night, police authorized the removal of Holley's body from the grave right after her funeral procession so that the man claiming to have seen her with Todd Henderson could make a positive identification of Holley. Another witness, an older black woman, also came forward at this time claiming to have seen the two together on the Monday night of her murder.

Further damning evidence came from Todd Henderson's wife. After the suspect claimed he had not owned a razor or pocketknife in the last year, police questioned his wife and discovered that, just the week before, she had borrowed his pocketknife. In terms of a razor, it was discovered that Todd Henderson in fact did own a razor and that, on Tuesday, the day after Sadie Holley's murder, he had taken his razor to a local barbershop to be sharpened, a service that many such shops offered in that era. Once again, this evidence, although circumstantial, did make it appear as though Todd Henderson was guilty of the murder of Sadie Holley.

In addition, evidence also surfaced that Henderson was Lena Sharp's killer. On the Thursday after Holley's murder, George Brooks, an African American who owned a refreshment stand in the Hanover Street area, claimed that he had seen a man fitting the description of Todd Henderson coming from the direction of Emma Lou Sharp's screams on the night of her attack and her mother's murder. He came to the station, where he positively identified Henderson, and along with him he brought a bloody rag, which he claimed Henderson had dropped on the street.

Another witness, W.R. Achison, a streetcar conductor who was working on the night of Holley's murder, finally surfaced after a long search by police. He claimed that Henderson was in the area of her murder as late as 12:55 a.m. the next morning. To the casual observer, it appeared that the police thought they had their man. However, they were still on the hunt for the killer, and there was still the matter of Henry Huff of Brotherton Street.

Huff appeared before a coroner's jury on the same morning that Brooks came forward with his evidence against Henderson. Police claimed that witnesses also saw Huff with Sadie Holley on the night of her murder. Was it possible that both Henderson and Huff had killed Sadie Holley? Or perhaps some of the eyewitnesses were confused? Did Henderson

and Huff look alike? These questions might forever go unanswered, for there exists no known pictures of the men. Were the police simply trying to hold these men in custody and forward the cases against them to quell the frustration of the city's white and black leaders? It appears that there was a lot of confusion surrounding these two suspects and the police's actions while they were in custody.

The City Continues to Live in Fear

A few days after the rewards were announced, Atlantans awoke to the news of more robberies, but this time, there was a connection—or so some thought—to the Ripper murders. The *Atlanta Constitution* ran a story on July 15 reporting that Atlanta resident James A. McCoy's home had been robbed during the night. Among the items that were said to have been stolen by a "negro burglar" were two sharp razors. The article went on to say that "a thorough search was made by the thief until he found them. Passing the slot gas master on his way out he secured several dollars in small change."

Later that week, Mayor Winn and the city council met at Taft Hall to conduct business. This would be the last time the council would meet there, for the council would soon be granted jurisdiction over the new city hall. However, at this meeting in Taft Hall, Mayor Winn presented a resolution to the council asking for a monetary reward for the capture of Atlanta's Jack the Ripper, making good on his earlier promise. The article reported:

> *The Mayor will send a special communication to the city council this afternoon asking that rewards be offered for the unapprehended perpetrators of the many murders of negro women committed during the last year. This is in answer to a petition presented to the mayor by many of the leading negro citizens of Atlanta.*

Examination of these statements leads to the conclusion that, on the mayor's part at least, there was suspicion that the murders were being committed by more than one perpetrator, or many perhaps, most of whom were still loose on the streets.

In the black community, leaders were not letting up either. On July 16, a meeting convened at Wheat Street Baptist Church for the sole purpose of drumming up support in the black community for an effort to help protect the women of the community from the Ripper. The papers reported that

> *a mass meeting in protection of Atlanta's negro women from the murderous attacks of Jack the Ripper was held at the Wheat Street Baptist Church yesterday afternoon at 2 o'clock. Several speeches were made by prominent colored ministers and citizens, and resolutions to the effect that everyone attending the meeting would lend their efforts in stamping out the crime were proposed and unanimously adopted. Those delivering speeches were: Rev. P.J. Bryant, Prof. P.C. Parks, Rev. R.D. Stinson, J. McHenry, H.A. Rucker, and others, all of whom deplored the many crimes of murder committed upon negro women.*

The next day, Reverend Henry Hugh Proctor preached a scathing sermon to a church full of worshippers in which he not only indicted the murderer but also the black community for creating such a climate where criminals might the streets of Atlanta. His text for the summer was the Old Testament Book of Daniel. The good pastor fired at his congregation that when a community the size of Atlanta suffers seventeen murders in a little over two years, there is something most definitely adrift. He proclaimed:

> *Let us be plain and frank. I believe these murderers are black men. The circumstances point that way. While many of the murdered women were hardworking and industrious, investigation shows that some of them were not what they ought to have been. This trouble, then, arises from the bad people of our race. But why do these people exist? In the first place, there is too much lawlessness in our community. Lawlessness begets lawlessness. The colored people are imitative, and especially quick to catch on to the faults of those above them. There are too many places of evil permitted in this community. Every blind tiger, gambling den and house of evil should be shut up. Near beer saloons have no rightful place in a prohibition state like Georgia. The abolition of the saloon was one of the best blessings that ever came to our people.*

The rest of his sermon focused on the failings of the "colored" church. He asserted that while the churches had been doing a lot of good work, "they have been getting people ready to die when they should have been preparing them to live." He wisely acclaimed that it was a sin that the churches were shut up six days a week, yet the places of ill repute are never shut up. Evildoers, he said, trod right by the closed doors of the churches on their way to the saloons and brothels in the black community. In Dr. Proctor's estimation, the work of the Ripper was nothing more than the judgment of God on the black community for its sins and misguided attempts to lift up its congregation but look the other way as the neighborhood fell into the fiery pits of hell.

Todd Henderson Is Held for the Murder of Sadie Holley; Will Not Be Tried for Lena Sharp

As the month progressed, there were developments in the case against Todd Henderson. The papers continued to report that though the case against him was compelling, it was still circumstantial. In terms of the case of Lena Sharp, the evidence was so weak and circumstantial—due to the fact that Emma Lou Sharp could not make a positive identification—that the defense attorney for Henderson succeeded in getting it dropped. The *Atlanta Constitution* continued to report the merits of the case against Henderson for the murder of Sadie Holley. "The evidence against Henderson consisted of a chain of identifications by a number of witnesses. According to them he was seen with the Holley woman Saturday night preceding the murder, was with her Monday night at 11 o'clock, and two hours later left the vicinity of the crime on a street car. This last fact was told by two street car men," the paper read on July 18, 1911. While it is true that these facts cast much suspicion on Henderson, none of this proved that he was the Ripper or that he had killed Sadie Holley. Nonetheless, in the early twentieth century, American jurisprudence did not have the reputation of being fair and equitable when it came to African Americans, a fact I am sure was not lost on

the attorneys for Henderson. The fact that police and the press were still touting the strength of the case against him must have made the Henderson attorneys more nervous.

Ripper Mania

As the evidence points out, the month of July seemed to be filled with Ripper mania. Not only did the murders of Lena Sharp and Sadie Holley take place that month, as well as the arrest of two main suspects, Henderson and Huff, but also the public seemed to be getting saturated with images of the serial killings and crime spree. In addition to meetings held in black churches around the city and meetings called in the white community of business and civic leaders, there was also much discussion about the Ripper on the streets of Atlanta. Perhaps more than anything, this was fueled by the constant attention given the subject by the mainstream press at the time.

The term "Ripper," which was in part a name given to the killer(s) by journalists, was now being used by most everyone. In fact, each time a murder or attempted murder was committed, police and the press questioned whether it might be the work of the Ripper. In fact, there were some interesting crimes that, while not attributed to the Ripper, were still labeled Ripper or Ripper-like murders. Perhaps the most notable one was reported by the *Atlanta Constitution* on July 18, 1911. The headline "Mary the Ripper, Has Jack Beaten to a Fare-Ye-Well" must have caused quite a chuckle among readers. The paper reported that "A 'Mary the Ripper,' who terrified one woman and threatened her life, was tried before Judge Broyles yesterday afternoon, and was given thirty days straight to remove her at least a short while from association with rational people." The assailant, a woman who seemed to have quite the temper, was reported to have said of her potential victim, "She needn't be scared of Jack. I'm 'Mary the Ripper,' and I'm going to git her."

Apparently, this "Mary the Ripper" frightened a woman at 58 Hunnicutt Street when she made repeated visits to the residence looking for a man. The woman pleaded for protection from this "Mary" because she claimed that "Mary" had quite the violent past. This was a claim that

"Mary" did not dispute but in fact corroborated by admitting that she had indeed been in trouble in Spartanburg, South Carolina, at one point for killing a man, though she was not convicted because of a mistrial. Her crime spree seemed to follow her from the Palmetto State, perhaps by way of Augusta, a large Georgia city that sits on the Savannah River and borders South Carolina. It was in Augusta that she allegedly shot her husband.

Upon hearing this, Judge Broyles became confused and asked, "Thought you said you had a husband here?"

"Mary" replied, "That's my Atlanta husband. The other one is in Augusta."

It appeared that the Ripper moniker was indeed being applied to some fairly strange folks, but folks who did have violent streaks nonetheless.

The Summer Moves On

As the summer continued to wax on, several other events unfolded. For one, the *Atlanta Constitution* reported on July 23 that the Fulton County police had arrested a suspect for the murder of Sophie Jackson. Prior to this report, the papers had made no mention of her murder. Apparently, Jackson was murdered on June 24. Fulton officer J.M. Carroll made the arrest, and according to the report, he had been investigating the murder and trailing the suspect, one Ed Ward, for the previous few weeks. It was also noted that Ward had several aliases, two being W. Cole and John Wesley. Carroll said that his suspicion was heightened after speaking with the deceased's father on the morning after her body was found.

Mr. Jackson reported that Ed Ward had been at the Jackson resident for several hours on the night of the murder. When he asked Ward to help him search for his daughter after she did not return home, Ward refused. Jackson mentioned in the article that Ward began to behave oddly. Jackson reported to Officer Carroll that Ward even went so far as to say that there was no use in searching for her, for he knew she was dead, and that if he helped look for the body and found it, people might begin to think that he was guilty of killing her. However, shortly afterward, witnesses reported seeing Ward go near the area where police

eventually found her body. In addition, Ward began to move around a bit, eventually having his belongings sent to Madison, Georgia, under the alias W. Cole.

Carroll hopped a train for Madison, where he immediately contacted local police. Staking out the local train station, Carroll awaited the arrival of the next train from Atlanta, and as suspected, Ward was aboard the train. Carroll made the arrest at that time, and Ward made a full confession of the crime. However, shortly afterward, he changed his story and said he had not killed Sophie Jackson. The biggest question about this story is whether Ward murdered Sophie Jackson, and if not, was she part of the Ripper serial killings? If Ward was the killer, was he responsible for more of the murders? The record is not clear, and not much more is mentioned about Jackson or Ward.

As July gave way to August, Fulton County prosecutors moved forward with their cases against Henry Huff and Todd Henderson. On August 9, the Fulton County grand jury indicted Henry Huff, but it also indicted a new suspect, John Daniel. Huff would stand trial for the murder of Sadie Holley. Very little information was given about the arrest, investigation and arraignment of Daniel. However, what can be said with certainty is that he was being held and indicted for a murder that was attributed to the Ripper. As these indictments were being handed down by the grand jury, things grew eerily quiet, and the Ripper murders ceased. However, this period would prove to be the quiet before the storm, for as August closed, another young black Atlanta woman would lie dead on the streets.

After Almost Two Months of Quiet, the Ripper Returns

The month of August had almost passed into September, and the Ripper struck yet again, this time after a lull of almost seven weeks. On the morning of August 31, the city awoke to news that Mary Ann Duncan, age twenty, had been found west of Atlanta in a community called Blantown. Like others before her, she was found near railroad tracks, and like Sadie Holley, her shoes had been removed and were missing. Sadly, her throat had been cut—a common characteristic of the grisly Ripper

murders that had plagued the city for the past eight months (some would argue longer). Friends of Duncan made the identification, and it was reported that she lived on Pittman's Alley.

The papers reported the story in early September. The *Constitution* noted, "After a lull of six weeks the crime wave in the city rose again Thursday night and another negro woman, the ninth in less than as many months was murdered by some 'Jack the Ripper,' who cut her throat from ear to ear." It went on to state that "two negroes were arrested by detectives yesterday, but there is no direct evidence to hold either, and one of them is held for the investigation of certain alleged statements concerning his knowledge of the crime." Police officials commented that they had evidence against the suspect that looked "promising." The paper made no bones about it. The editors insisted that the murder looked strangely like the Ripper murders of the previous months, especially given the unusual brutality of the attack.

Other characteristics they insisted the murder shared with previous ones was that this one was also carried out in a remote and lonely spot, near a railroad, and was against a victim from the same demographic group. Indeed, they were correct. Blantown was a remote location between the Southern and the Atlanta, Birmingham and Atlantic Railroad tracks. Also very eerie was the fact that the killer had taken the victim's shoes, just like the killer had done to Sadie Holley. If this murder was committed by the Ripper, did this mean that Huff, Henderson and Daniel were all innocent? Or was it possible that they were guilty of the murders for which they were accused and a new assailant had picked up where they left off? The latter would not be impossible given that the details of the murder were being discussed quite frequently, as well as being published in all of the city's mainstream papers, in both the black and white communities.

Further into the fall, the Ripper struck again, this time using a different murder weapon. Strangely enough, Ellen Maddox, a cook for an Inman Park family, was attacked while on her way home from work. She was attacked near the Atlanta Stove Works on Irwin Street; her assailant hit her on the back of the head with a blunt object. The attack was so brutal that the papers reported, "She was attacked from behind, her head almost crushed and her face beat out of all resemblance to a human

being. Not once did she catch a glimpse of her assailant." Officers West and Brannen were called to the scene of the attack at about 7:00 p.m. that evening. Maddox was sent to Grady Hospital, her condition quite serious. Although she was badly beaten and near death, she was able to tell officers, "He ran up behind me and hit me and then—" She was unable to finish her sentence, and no word was given in these reports as to whether she died as a result of her injuries.

Atlanta Officials and Leaders in the Black Community Grow Even More Impatient

The cooler weather brought more than just falling leaves and crisper air to Atlanta; it also brought about another brutal slaying. If the Ripper was still at large, his next act of violence was even more ghastly. In early November, children stumbled upon the body of Minnie Wise in a field near Connally Street and Georgia Avenue. This is the same area where two other victims had been found. Like Sadie Holley and Mary Ann Duncan, the victim was found shoeless. Police later stated that her shoes had been cut off and removed. Other details of her murder included that she had been hit in the head with a heavy object, her body had been dragged for some distance and her middle index finger had been cut off near the joint. The mutilation of Wise baffled police.

As the report of these most recent deaths hit papers, Atlanta was once again caught in the grip of fear and anxiety. It would not be long before the citizens would turn to their local elected officials for both help and answers. As pressure mounted on the mayor and city council, word of the murders made its way around the country. Letters began coming in to the mayor's office, as well as that of the local police, offering assistance in catching the fiend, or fiends, responsible for these grisly attacks on the young black women of Atlanta. It is certainly understandable that such a thing would ruffle feathers—and it did, as evidenced by Mayor Winn's response. Mayor Winn wrote, "Atlanta is known throughout the country as one of the most law-abiding cities of its size in the United States, and its police and detective departments are second to none." As the mayor took a sharp tone in his response to critics and those offering help from

the outside, leaders in the black community used this time to renew their calls for help and for the hiring of black detectives to assist in bringing in the murderer(s).

Almost as if he were responding to this public scene of confusion and dismay, the Ripper struck again less than a week after the mayor so eloquently defended his city and its police force. This time, the victim's corpse was left in a state beyond gruesome. A young woman was found in the city with her head almost completely cut from her body. In addition, the murderer disemboweled her, cut out her heart and placed it beside her body. This most recent slaying brought about much frustration in the city, particularly among the men of law enforcement; however, the response they gave was not always appropriate.

In a story published by the *Atlanta Constitution* on November 23, 1911, titled "Negroes Know More than They Tell, Say Sleuths," the anger of some law enforcement officials could be felt; however, the unnamed detective interviewed by reporters directed his anger broadly at the black community and issued statements that were quite racist and ridiculous. The unnamed detective told reporters, "We won't get to the bottom of this thing until we get some help from the negroes." He went on to say:

> You can't trace the murderer with dogs, and there are no clues around the body. We find out who she was intimate with, who her lover was, and that is about all that any man can find out unless he could get down in and among the negro population and hear the talk that is going on. These murders are being committed among the lower class of negroes, ignorant, brutal beasts that know nothing else. Their acquaintances are afraid to talk, but if there was a little money slipped them we could find out invaluable clues, and I wager we would land the murderers.

In an interesting side note, that same week, the Atlanta papers also carried a story from South Georgia. In the town of Waycross, the county seat of Ware County at the Georgia/Florida border, a black woman was discovered murdered. Her name was Sally Applewhite, and her mutilated body was found in her home. The local police picked up her husband, Will Applewhite, and another black man, only identified in the report as Cooper, on suspicion of the crime. It was revealed that Will Applewhite

NEGROES KNOW MORE THAN THEY TELL, SAY SLEUTHS

"We won't get to the bottom of this thing until we get some help from the negroes," said one of the best known members of the detective department last night in discussing the so-called "Jack the Ripper" outrages which have caused the death of thirteen negro women in the past seven months.

"Look at it yourself," he continued. "All you know or we know is that a woman is murdered. You can't trace the murderer with dogs, and there are no clues around the body. We find out who she was intimate with, who her lover was, and that is about all that any man can find out unless he could get down in and among the negro population and hear the talk that is going on.

"These murders are being committed among the lower class of negroes, ignorant, brutal beasts that know nothing else. Their acquaintances are afraid to talk, but if there was a little money slipped them we could find out invaluable clues, and I wager we would land the murderers. The same thing is done everywhere else in the world, and I know of a negro, intelligent and reliable, who would help me for bare expenses. But we haven't got the expenses."

There was no discouragement or criticism evident in the conversation but more than once the lack of funds in the department has handicapped the work and taken the spirit out of the men who were working overtime to develop the case. The negro murders has reached such a point that it is not unlikely that several citizens may be asked to contribute a $100 or so to be used in the work as above stated.

As this article from the *Atlanta Constitution* points out, there was a lot of mistrust between police and the public during the murder investigations.

had left his wife, but interestingly enough, he was also, at the time of the murder, looking for insurance papers. The police also believed that robbery was committed after the murder, which could have been the motive. While it is certainly clear that the Atlanta murders were not committed by Applewhite and Cooper, it is interesting that local officials in Ware County, as well as the Atlanta press, were not using the term "Ripper" sparingly. It looked as if the Atlanta episode was becoming as much of a legend as the one in London some decades earlier.

Once more, black clergy, black civic leaders and the black business community felt dismayed by the police's inability to bring the murder spree to a halt. On November 26, a meeting was held at Big Bethel Church to discuss the issue. At this meeting, a large sum of money was raised to offer as a reward for the apprehension of the killer. This money was added to the monies already raised in the black community. Also at the

meeting, it was heavily suggested that the women of the community stay indoors at night. Jackson McHenry, C.M. Manning and Reverend C.M. Tanner were among the speakers pleading the case to the congregants. They all stressed that the one way to stop this "Jack the Ripper" was for all the women of the black race in the city to be even more careful as they traveled and to stay off the streets after nightfall. C.M. Tanner proclaimed, "As long as 'Jack the Ripper' stays at large, his misdeeds will be carried on. As his mania for killing seems to be directed at women alone, his murders can be checked through them. Stay indoors, and your lives will be saved, for venturing out at night moans only to invite the monster's ravages." As difficult as this advice was going to be to follow given that many of the young black women of Atlanta had domestic jobs that required them to travel during the nighttime and early morning hours, it was a logical conclusion for the leaders in the black community to reach. It also further illustrated the lack of faith that these leaders had in the city police.

The end of the month also brought about the climactic end to the trial of Henry Huff. On November 29, the *Atlanta Constitution* reported that the trial was coming to an end and that the verdict was forthcoming within a day or two. The report made it clear that the case against Huff was not quite as solid as the state had once thought. The paper reported, "It was thought that the state had a pretty clear case against Huff, but the negro's attorneys Tuesday succeeded in accounting for the blood upon the negro's clothes, their witnesses offered an alibi, and in addition a number of reputable white business men of Atlanta testified to Huff's good character." The paper went on to reveal, however, that the state was able to prove that Huff had been very intimate with Sadie Holley, the woman whom he was being tried for killing. They also were able to produce witnesses that put the two together on the day of the murder. However, as most jurists can attest, being together on the day of the crime is not enough evidence to convict someone beyond a shadow of doubt.

Still, this was Atlanta in the early 1900s, and Huff was African American. Justice might not be applied in his case as consistently as it would in the case of a white man. But Lady Luck smiled on Huff, and the jury found him not guilty of the crime. There just simply was not enough evidence to convict him. The sentiment throughout Atlanta was that he

was not the Ripper and that he more than likely had nothing to do with the murder of Sadie Holley. Henry Huff became a free man.

In another interesting turn of events, that same article reported that another man, Bud Wise, had been indicted by the grand jury as the Atlanta Ripper. No other details were given about him or the crimes for which he was being held.

Another Month, Another Attack

As the year drew to a close, another young African American was found nearly dead, a possible victim of the Ripper. This time, it was Zella Favors. Witnesses found her nearly lifeless body on the front porch of her home at 36 Taylor Street. Although alive when discovered, it was reported that she was so badly brutalized that she had little chance of survival. Police took her to Grady Hospital. The local police force assigned two detectives to the case, and shortly after Favors was taken to Grady, the detectives discovered a trail of blood from the front porch of her house all the way to Pratt Street. Witnesses claimed to have seen her on that street earlier on the night of her attack talking to a man. Witnesses heard part of the conversation, enough to hear the man say to Favors, "Jack the Ripper ain't dead yet."

Police immediately laid the blame for the attack on the Atlanta Ripper. Did Favors come face to face with the fiend? Were his word, "Jack the Ripper ain't dead yet," a pronouncement that he was the Ripper? Or were they simply the musings of a deranged man who found delight in the stories of the Ripper and decided to imitate his bloody deeds?

A few short days after the attack, Reverend Henry Hugh Proctor took to the pulpit again to denounce the crimes and the fact that police had still not landed a definite suspect. His sermon, entitled "The True Attitude of the Christian People Toward Crime and the Criminal," was meant to try one more time to stir the people to action. Workers in the church also tried to raise money to pay for a special detective force to aid in the hunt for the murderer and bring an end to the spree. They also renewed their pleas for the city to hire black detectives to the police force to help in the search. It was with these pleas that the bloody year of 1911 came to a close, but the next few years ahead would not be much better.

4
BEYOND *1911*

As 1911 came to a close, the papers reported that no fewer than fifteen victims had been taken by the Ripper. Although city and county police had tried their best, they still fell short of stopping the murder spree gripping the city. Leaders in the black community had done all they could to assist the effort, although many of their pleas to have the city hire black detectives who would be dedicated specifically to the Ripper case had gone unanswered. Though much reward money had been offered by both the governor and local black churches, no suspect had been convicted for the crimes. Henry Huff and Todd Henderson had both been tried, but Fulton County juries had found them innocent. As the new year dawned, many hoped that things would change. Although the murders would happen with less frequency, they continued to happen.

1912

As the winter of 1912 rolled in, the murdering rampage of the Ripper continued. On January 20, Pearl Williams's body was found at Chestnut and West Fair Streets with her throat cut from ear to ear. The paper simply reported that the murderer was uncaught. The crime fit the pattern of the Ripper, and police felt this was his first victim of the year. On February 17, 1912, the *Atlanta Constitution* reported the death of

Beyond 1911

another young Atlanta woman: Alice Owens. A resident of Piedmont Avenue, Owens's body was found with her throat cut from ear to ear. Like with so many others, the murderer had grossly mutilated her body. The report indicated that the young woman had been killed on Bowen Avenue not far from the Jonesboro Road, an area about two hundred yards outside the physical city limits. The murderer had dragged Owens's body into a gulley near Bowen Avenue. Police began investigating the murder, and soon afterward, Owens's husband, Charlie, was arrested for the deed. In addition, two more men were arrested on suspicion of being involved in the murder. They were James Jones of 219-A Jonesboro Road and John Jenkins of 196 Thayer Street.

One week later, Charlie Owens was still being held by authorities. An interesting side note in this same article pointed out that Owens was the sixteenth in a series of crimes in the last few years. However, it went on to say that there had been a conviction for the fifteenth murder. A man by the name of Lucky Elliot was reported to have been tried and convicted for that crime. Although few details were given in that report, an article in the New Year's Day 1913 edition of the *Atlanta Constitution* revealed that Lucky Elliot was indeed accused of the murder of Ida Slade, whose body was discovered on January 12, 1912. If Elliot was considered a main suspect in the Ripper murders, the papers did not say. All that can be ascertained is that he was held to be guilty of this murder at least, and the press and police did not attribute additional murders to him. This means that the Ripper was still on the loose.

In a report from the *Atlanta Constitution* on February 18, it appeared that the fiend was now threatening northeast Georgia—Hall County and specifically the city of Gainesville. The paper reported that the chief of police had received a letter on February 16 from the "Black Jack the Ripper," no doubt a reference to the murders in Atlanta. The letter warned that the Ripper was about to invade Gainesville and take his crime spree with him. He made specific reference to the black women of the city in his letter. The paper stated that the writer specifically wrote to the mayor, saying, "Dear Sir: I will soon visit your city. Undoubtedly you have heard of my work here in Atlanta. It has not been a consequence to what I will do in Gainesville. You had better prepare for me, and see that the negro women behave." Police in Gainesville no doubt considered the

letter a joke, but it most definitely had an impact on the community once word of its existence got out. The paper stated:

> *Much trouble is being encountered by white people in the service of negress cooks, the majority of whom have been afraid to leave their homes after dark. The police treat the letter as a joke, and are of the opinion that an Atlanta negro is trying to frighten local negro women. However, Chief Smith stated today that precautions would be taken against possible outrages.*

It was never proven if the Ripper planned to go to Hall County or not, but he most certainly made an impression there.

As spring arrived, so too did a peculiar conclusion about the Ripper murders from the Fulton County Grand Jury. On March 3, 1912, the papers reported that the grand jury had examined all the cases attributed to the Ripper and arrived at the conclusion that there was no Atlanta Ripper. Saying that "Ripper Jack" was nothing more than a myth, the grand jury declared that each murder had been committed by a different man. Apparently, the jury had been studying these cases for two months. The *Atlanta Constitution* reported:

> *The jury declares that after a close study of the cases it has arrived at the conclusion that each murder was committed by a different man, and that in each case it was the result of jealousy following immoral conduct. In almost every instance, the presentments declare, the woman killed was either separated from her husband or was single, at the same time being guilty of immoral conduct, and that it was almost every case the result of revenge following jealousy.*

These ideas bring back images of the sermon given by Reverend Henry Hugh Proctor of the First Congregational Church in July 1911, when he proclaimed that upon investigation, some of the murdered women were not "what they ought to have been."

On Easter Sunday, news spread that the Ripper had claimed yet another victim. This time, the body was discovered by two young African American men walking through a field near Pryor Street on their way to

Easter services at their church. The papers called the victim a nineteen-year-old octoroon (a term meaning that she had one great-grandparent of African descent) girl. She was found face up in a cluster of bushes near the road. There was a deep cut on her neck, and her skull was bashed in. It was decided that the murder had taken place the night before. Searching the area, police found the spot where she had been attacked, and there were definitely signs of a struggle. According to police, during the struggle the assailant had stabbed the victim in the neck with a knife. The papers did not identify the victim, but the next January, a detailed report ran in the *Atlanta Constitution* indicating that a Mary Kate Sledge had been murdered on April 6, 1912, by the Ripper. As April 6, 1912, was Easter Sunday, it is more than logical to assume that Sledge was the aforementioned victim. That same article reported that the murderer was never caught or at least had not been apprehended at that point in time.

The murder of Sledge on Easter weekend was not the only Ripper murder that spring. Also reported was the murder of an unidentified woman whose body was found floating in the Chattahoochee River. Like the other women, her throat had been cut and her body mutilated. The papers identified her simply as a fifteen-year-old octoroon.

Later that month, a Fulton County jury found Charlie Owens guilty of the murder of his wife, Alice Owens. Owens had been in custody since he was picked up in February on suspicion of being his wife's killer. This meant that he was definitely not the killer of Mary Kate Sledge. If the jury finding him guilty was correct, and he did kill his wife, further developments showed that he was not the Ripper—or perhaps the Ripper was not just one person.

Additionally, though few details were given, the papers reported the murder of Marietta Logan, also known as Mary South, whose body was found with the throat cut near Atlanta Avenue and Fraser Street. Indeed, the Ripper murders were not over.

As the year moved on, other developments occurred that brought more attention to the plague gripping the city. In the *Atlanta Constitution* of August 7, 1912, the press reported that police in Marietta had found a victim whose death seemed to mirror those of the women murdered by the Ripper in Atlanta. The paper read:

Jack-the-Ripper theories are advanced for the murder of a young negress, supposed to be from Atlanta, whose body was found today beside the Seaboard tracks about 6 miles from this city and about 2½ miles west of the Chattahoochee river. She had been knocked in the head and the trunk slashed with ugly gashes. The girl was a dark mulatto, not over twenty-five years old, and weighing about 116 pounds. She was dressed in white, with pale-blue stockings and white slippers.

Like in the case of the Waycross murder in November 1911, the press seemed to be using the Ripper moniker to categorize murders in other places. However, the crimes did match those that were being carried out in the Gate City.

The Waycross murder was solved when the victim's husband was found to be her killer, but the Marietta murder did not appear to get solved, so some were led to believe that the Ripper had taken his ghastly show on the road and was now stalking young black women in Cobb County. However, others pointed to this case in Marietta to uphold their theory

"RIPPER" IS BUSY IN ATLANTA AGAIN
The Atlanta Constitution (1881-2001); Sep 2, 1911;
ProQuest Historical Newspapers: The Atlanta Constitution (1868-1942)
pg. 7

"RIPPER" IS BUSY IN ATLANTA AGAIN

Another Negro Woman, the Ninth Victim, Found Dead.

After a lull of some six weeks the crime wave in the city rose again Thursday night and another negro woman, the ninth in less than as many months, was murdered by some "Jack the Ripper," who cut her throat from ear to ear. She was not identified until late yesterday afternoon, when friends said that she was Mary

The fiend was tagged the "Ripper."

Beyond 1911

that the Ripper was not necessarily one person and that the crimes in Atlanta had become so sensationalized that they were spawning copycats.

Finally, in August, the Atlanta press reported that the local police had caught the man they felt was guilty of the Ripper murders, minus the ones that could be directly attributed to husbands, such as the Alice Owens and Lucinda McNeal cases. On August 11, 1912, the *Atlanta Constitution* announced that "Jack the Ripper [Was] Believed to Be a Modern Bluebeard with 12 Wives as Victims." The article started with a question: "Is Lawton Brown, a lanky, well-dressed negro, with small, sharp eyes that dart about nervously as though he were in perpetual fear, a modern Bluebeard, who has murdered a dozen wives within the past year?"

Police arrested Brown and held him in custody. Shortly afterward, he made a complete confession to the murder of Eva Florence, a woman who had been killed in November 1911 on Cunningham Street in Atlanta. Detectives Coker and Hamby were the two sleuths assigned to the case, and not long after they hauled in Brown, they began putting together an even bigger case against him, one that focused on more than just the murder of Eva Florence. He was now being held on suspicion of twelve of the Ripper murders from the past few years. In a really interesting twist, police said that they believed not only that Brown had killed these twelve women but also that he had been husband to all of them and lived with each of them individually for a short time. Dr. M.C. Martin was hired to evaluate the prisoner, and his assessment was that Brown suffered from an unexplainable mania. As police pressed Brown for information, they noticed that he was very familiar with all of the so-called Ripper murders in the Atlanta area. He could name the locations of the murders, the victims and the methods of assault. He even went so far as to say that he had been a witness to two of the murders and then proceeded to describe them in graphic detail. He stopped short of admitting to any of the murders, except the murder of Eva Florence. When asked why he did not assist the victims of the murders he had witnessed, he simply said that he had not done so out of fear.

So where did police get the idea that Brown was the Ripper and had at least twelve wives? This idea was planted by two women who came to the police station claiming to be his wives. One woman said that the whole

time she had lived with him, she believed that he was the murderer the so often decried in the daily papers. She said that it was a great relief to her that he was caught and was behind bars. The other woman, a cook—the same occupation as several of the Ripper's victim—said very little but did show concern over his situation. Detectives asked Brown about these developments, but he offered nothing by way of explanation.

On another note, Brown showed the detectives his knife, a weapon they believed he had used to slit the throats of so many young black women in the last two years. The knife had been found near the body of Eva Florence, buried in the ground. It is unclear how Brown got it back to show police.

The more police spoke to Brown, the more they felt that they had the right man. He seemed to be suffering from dementia and fit the bill of a deranged killer. He also incriminated himself when he came home on the night of Eva Florence's murder with blood on his shirt and in a hurry to dispose of it, according to one of his "wives." In addition, this wife shocked police by telling them that this was not the first time he had come home with blood on him. In fact, he had come home on many Saturday nights with blood on his shirt and took great pains to clean it off by the fire. What is interesting about this, in addition to the bloody shirts, is the night on which it customarily happened: Saturday. Most of the murders took place on Saturday evenings.

As police were riding high on their capture of the Ripper, the other shoe dropped. In October, Brown went on trial, but as had happened with Henderson and Huff, the jury did not convict him. Brown underwent a lengthy trial presided over by Judge L.S. Roan. During the trial, much doubt was cast on Brown being the murderer due to his mental condition. His defense postulated that Brown was confessing to these murders simply for notoriety, an assertion that was backed up by witnesses who testified that Brown was indeed mentally disturbed and was also more than a bit conceited and much the braggart. The defense also produced a witness, John Rutherford, who testified that Brown had been forced into a partial confession by police and that he was prone to hallucinations and would confess to almost anything under pressure. The jury believed this evidence and returned a not guilty verdict. It seemed that police did not have their man. The Ripper, or Rippers, was still on the loose.

Beyond 1911

1913

While not as bloody as 1911, the year 1912 rolled out, but there were still enough murders to keep the city on edge. As the New Year dawned, the press continued to highlight the crime spree embracing the city. Atlanta readers awakened to the *Atlanta Constitution* headline: "Blood Flowed in a Crimson Stream During Year 1912." The headline is a bit misleading. The report is not just about the Ripper murders but included details of all the loss of life via crime in that year. However, a part of the article was indeed devoted to the figure that the press named the Ripper.

Thus far, 1913 had gotten off to a quiet start, but like the previous year, the springtime brought more murder to the capital. First, Atlanta papers reported the death of a woman named Laura Smith. The *Constitution* carried a short article about the slaying. It reported:

> *The nineteenth murder of its kind within two years, and the third of 1913, all of which have been attributed to the mysterious and uncaught "Jack-the-Ripper" was revealed by police yesterday morning when the body of Laura Smith, a mulatto, was found in the alley near Pine street and Meritts avenue. As in all others of the unsolved murders, her throat was slashed and her body badly mutilated, apparently with a keen-bladed knife or dagger. A coroner's inquest will be held sometime this morning.*

Like so many of the former victims, Smith was a servant in the home of a family, her employers living on Ponce de Leon Avenue. She was on her way to work when she was killed. The paper reported that Smith was the third such murder of 1913. Few details exist of the previous two.

In August of that year, the Ripper seemed to strike again. His victim was Martha Ruffian, who at one time had been a maid for a Mrs. Daisy Ople Grace. Interestingly enough, Martha Ruffian had also been a witness in the trial of Mrs. Grace, who was accused of killing her husband. Police reported that Ruffian lived in a house in an alley off Ponce de Leon with her husband, J.C. Ruffian. The two had been separated for over a month. J.C. Ruffian had also been a witness in the Grace trial, as had a butler in the Grace's home. Martha Ruffian was killed in her home and then

dragged through a pea patch for about fifty feet. A trail of blood was discovered that led police to piece together this part of the crime. Her body was found in a clump of bushes with a single knife wound in the throat. The murderer had sliced through her jugular vein. Police did have a lead on one suspect, Alex Smith, a black man who was said to have been intimate with Ruffian in the days before the murder.

This murder appeared strange to police. While it was committed in much the same way as the other Ripper murders, the victim was killed in her home, which was quite unusual. Another victim had been found on her front porch, but almost all the other Ripper victims had been killed in dark, desolate places on the streets of Atlanta. Some had been dragged from their place of murder, like Ruffian, but since her murder happened inside her own home, police believed it was a crime of passion, perhaps committed by Smith. Nothing was definite, however, and the murder was still being listed as part of the Ripper's rampage through the city.

It seemed that the year was a quiet one in terms of Ripper murders. There were several possible explanations for this. The most logical, of course, was that the murderer wasn't as active. However, another murder took place that year that took a lot of attention away from the crime spree in the black community: the murder of Mary Phagan.

On April 26, Confederate Memorial Day, thirteen-year-old Mary Phagan was murdered at the National Pencil Factory on Forsythe Street in downtown Atlanta. Phagan was an employee of the factory. She had been working there while awaiting enrollment in a local school that did not have enough space for new students at the time. On the day of her murder, she had gone to the pencil factory to receive her week's pay: $1.20. Later, she planned to meet friends to watch the Confederate Memorial Day parade being held in the city. She never made it that far. That night, factory workers found her lifeless body in the cellar, bruised and battered. It was later rumored that she had been sexually assaulted as well.

As news of the murder spread, residents of the city were stunned. Not only had they been hearing the details of all the Ripper murders in the black community on a regular basis, but they had also been dealing with a rash of robberies perpetrated by a gang of thieves. The years 1911 and 1912 had been called some of the bloodiest years in Atlanta history, apart

Beyond 1911

from the Battle of Atlanta itself, and now a young, innocent, thirteen-year-old girl lay dead in a pencil factory in the heart of the city. The city felt violated and desecrated along with the child.

As police investigated the crime, the manager of the factory, Leo Frank, emerged as a suspect. He was the last person to see Phagan alive, and when police visited the Frank home to discuss the murder with him, they noticed that he appeared nervous. Later, the night watchman told police that Frank had called him during the evening to see if everything was all right at the factory—nothing abnormal, but in this case, it was the first time he had ever done so. This aroused the police's suspicions.

Jim Conley, a black man who worked at the factory, was seen washing bloodstains out of his shirt. When questioned, Conley confessed that he had helped Leo Frank dispose of the body after Phagan was murdered. Even though some of Conley's stories were contradictory, police had enough to make an arrest, which they did. Frank was Jewish, and some believed that he was accused because of the strong anti-Semitism that prevailed in the South at that time. Many northern factory owners and managers were resented by the local working class. The workers felt that they were being taken advantage of by these wealthy landlords from the North, a sentiment that was no doubt grounded in the Reconstruction era, when many carpetbaggers came south to make a quick buck after the depravation of the war. Many such northern industrialists were Jewish, and Frank's religion certainly did not help his case.

Other scholars believed that Frank was either guilty of the murder or guilty of the coverup. They point to Conley's testimony, the fact that Frank was nervous when police questioned him and that he at first denied knowing Mary Phagan, even though she had worked in the factory almost a year and had been paid directly by Leo Frank. Other witnesses said that Frank would "flirt" with Phagan at times, even going so far as to pat her on the back. There was no way he did not know her. Whether Frank was guilty or innocent, his became a household name, and the investigation and trial that followed became more about him and southern resentment than about the death of an innocent thirteen-year-old child.

Another byproduct of the murder of Mary Phagan and the Leo Frank case was that, for a while, attention shifted away from the Ripper crimes to coverage of the Frank ordeal. As Frank was put on trial for Phagan's

murder, not only was the attention of the city and state focused on the events, but so too was the attention of the nation. The Atlanta Ripper was still talked about, but not to the extent he had been before the Frank case. A search of the archives of the *Atlanta Constitution* turns up hundreds of articles about the murder and ensuing trial. Typing in the words "Leo Frank" turns up over five hundred hits alone. Had the Ripper lost his audience?

1914

The next year started off quite oddly in terms of the Ripper saga. While the city was still in the midst of the Leo Frank ordeal, the Ripper made another appearance, but this time, it was not with the slaying of a young black woman. This time, he communicated with the police through writing.

It appears that the killer, or someone pretending to be the killer, attracted the attention of police by way of the city's firefighters. On the night of March 7, 1914, firefighters at Fire Station House 2 received at least three false alarms. Between midnight and 1:00 a.m., someone pulled fire alarms at fireboxes around the city. All three alarms came from the south side and from fireboxes that were all in proximity to one another. The first came from the box at Washington and Love Streets. The second emanated from Washington and Jefferson Streets, and the third rang out from the box at Whitehall Terrace and Richardson Street.

A Chief Courtney investigated the third alarm. There at Whitehall and Terrace, he found a note signed by "Jack the Ripper." On the card, the Ripper issued several threats. First, he threatened to cut the throats of all Negro women he found on the streets of the city after a certain time of night. He also issued a warning to the pawnbrokers of the city and even went so far as to threaten the city's entire female population. He further said that all idlers (probably the homeless and drunkards) on the streets of Atlanta should beware of his wrath. Police felt that the card had been pinned to the first two alarms, but the wind had more than likely knocked them down before firefighters arrived, thus thwarting the delivery of his message. The third alarm was pulled, and police were able to arrive before the note was carried away.

Beyond 1911

Later, in March, it seemed that the police and press in Atlanta thought the Ripper had picked up a new hobby in addition to his murdering rampage. In an article in the *Constitution* on March 19, 1914, with the headline "New 'Jack the Ripper' Now Held on the Charge of Robbing High School," a new suspect had been picked up by local police in conjunction with a robbery on the previous Monday night at the local high school for girls. The thief absconded with valuable rugs and art squares—an odd horde for a mass murderer. He did not leave the school, however, until he pinned a note on one of the walls issuing a death warrant for five girls. A suspect was arrested in the town of Palmetto, a small town in the southern reaches of Fulton County southwest of Atlanta. The suspect, one Arthur McElroy of 289 Ira Street, Atlanta, was picked up after attempting to sell the rugs to a Palmetto merchant. The merchant, having read about the burglary and note on the wall, became suspicious when the merchandise fit the description of the stolen loot described in the papers, called police and reported the attempted transaction. Police brought along a witness when they came to Palmetto. A black janitor at the high school positively identified the rugs and squares. As news of the death threat left by the thief made its way through the area, girls at the school became reluctant to attend classes. However, the paper reported that that fear eased once McElroy was brought into custody.

Was McElroy the thief who had committed the burglary? If so, was he just toying with the officials at the school by placing the note on the wall claiming to want the lives of five girls in the school? Was he trying to copycat the Ripper, or was he the Ripper? It is quite possible that he was not associated with the Ripper at all and that his crime was just a thing of his own creation. But what does appear to be true is that any time a black man was caught up in a crime like this (specifically one involving the death of or death threats directed at young women of color), the term "Ripper" would be invoked. As for whatever happened to McElroy, the paper gives scant details. However, an article appeared the next day rehashing the events and adding that among the articles collected in Palmetto were candlesticks, vases, jardinières and clothing. This was a more exhaustive list than had been placed in the paper the previous day. The article also clarified that the suspect, McElroy, had been attempting to sell these wares to the "colored" population of the city, which indicates

that the merchant who called in the report was more than likely African American. Interestingly, Police Chief Jenkins reported that the initial arrest was made for selling goods without a license.

The summer in Atlanta began quietly. But after Independence Day, the Ripper murders began again. The week of July 19 saw the killing of two more women, both of whom were murdered in the style of the Ripper. The first occurred that Sunday, July 19. An Officer Haslett reported that a young woman had been found dead in the Murphey woods in the city. He reported that she had been killed in the Jack the Ripper style, with her throat cut, but this victim also suffered a bit of a different fate—one of her breasts had been slashed with a knife. Later that week, on Tuesday, another woman was found in a stretch of woods near Hill Street. Her body was lying half submerged in a small stream of water. A bullet hole was found in her head, and large footprints that appeared to belong to a man could be seen near her body on the banks of the stream. There was indication of a struggle. The police were tipped off by a phone call to police headquarters that a woman's body had been found. But when police arrived, they found the area deserted, and no one was there to show them where the body was. They followed the directions given in the phone message, which eventually led them to the body.

It appeared that the general public had not forgotten about the Ripper, even though he had been much quieter than in the past few years. Perhaps the newspaper reports of the most recent murders reminded some in the community that the killer might still be at large. Over time, his image grew even more popular, as evidenced by those who were openly trying to imitate him, men like Louis Drake. On July 25, police reported the attempted murder of one Anna Drake, a black woman who was rushed to Grady Hospital with deep cuts to her back, right arm and right thumb. In the early hours of the evening, Louis Drake, her husband, told her he was going to play "Jack the Ripper" with her. Then, he proceeded to cut her. Afterward, he left for the home of his cousin before departing to Florida, according to the victim's sister, Emma Ellis. Ellis had followed Drake for about five miles so that she could report on his whereabouts. Then she reported the crime to authorities. A manhunt commenced for Drake.

Although this was not a Ripper murder, the term was used to describe what happened, and the assailant himself had invoked the name of Jack

the Ripper as he committed his crime. It appears that the Atlanta Ripper phenomenon was taking on a life of its own.

On July 27, the papers reported that another black woman's body was found in the woods in the city. The *Constitution* mentioned that "a negro woman was found dead in the woods north of the junction of Greensferry and Lawton streets by Detectives Chewning and Sturdivant, shortly after 9 o'clock Sunday morning. Her throat had been cut, and her body slashed in several places, in 'Jack the Ripper' fashion. The coroner was summoned, but the identity of the negro woman has not yet been established." That identity, however, was soon discovered. A report later that week in the same paper proclaimed that not only had the woman been identified but also a suspect had been brought in by police. The victim's name was Mary Roland, and the Monday following the murder, police arrested Henry Harper on suspicion of the crime. Police claimed that he was apprehended in part because his foot was the same length as the footprints in the dirt near the body. No mention was made of whether Harper was tried and convicted for the crime or whether police suspected him for any other murders than Roland's. But for the rest of the year, the papers were quiet about Ripper murders. As far as one can tell, the Roland murder was the last of 1914 to be associated with Atlanta's version of Jack the Ripper. And in some circles, this murder is often said to be the last one period in the crime saga known as the Atlanta Ripper Murders.

1915

As easy as it would be to end the story with Mary Roland's murder and claim that the Atlanta Ripper saga had come to an end, one cannot help but see the similarities in other murders committed in the few years following the grisly attack on Roland. A year after her murder, papers in Atlanta reported another attack on a young black woman, and by the headline, it was no secret that the Ripper was still on the minds of the Atlanta press. In "Another Victim Taken By 'Jack The Ripper,'" readers learned that

> *after an absence of months, "Jack-the-Ripper," that will-o'-wisp murderer whose midnight activities have baffled the city in years gone by, again made his appearance in Atlanta Saturday night. Police officers, early Sunday morning, found the body of a negro woman, which had been slashed in several places with a razor, or very sharp knife. The body was lying in a ditch alongside the road at Sixteenth and Cherry streets. The negress so far is unidentified.*

Police commented to the paper that "the murder had every aspect of the old 'Jack-the-Ripper' murders of several years ago." Apparently, the police and press did not think the Ripper was done.

The next month, yet another murder was being attributed to the Atlanta Ripper. In "Ripper Busy Again; Another Negro Woman Victim of the Slasher," it was reported that the

> *discovery near the corner of Ponce de Leon and Penn avenues of the body of Lucy Farr, a negro woman employed at 207 Bedford place, at 7 o'clock Sunday morning, leads the police to believe that another "Jack the Ripper" crime has been committed in Atlanta. Police headquarters was notified early Sunday morning by a negro that he had found the body of the woman, and that she had evidently been stabbed in the head several times.*

This murder certainly shared many characteristics with previous murders attributed to the Ripper. First, the body was found on Ponce de Leon, a place where a few of the previous victims had been found. Second, the woman had been stabbed, though while most of the Ripper victims had their throats slit, this victim died of knife wounds to the cranial area. Third, the murder happened either late Saturday night or early Sunday morning. Most of the Ripper victims were killed on those days. There were just too many similarities for police to completely throw out a possible connection, which, of course, led many sleuths and citizens alike to believe that the Ripper was still at large—or that someone was carrying on in his fashion.

The last victim attributed to the Ripper of 1915 was found in perhaps the strangest of locations. In early September, police were summoned

Beyond 1911

to a convict camp on Virginia Avenue, where a young black woman's body was found. To add insult to injury, her lifeless corpse had been dumped into the camp's hog pen. While there were no marks on the body to indicate that the woman had died violently, police did deduce after further examination that her neck had been broken with a heavy instrument. Like the other victims, she was discovered on a Sunday morning, most likely after having been killed on a Saturday evening. She was found by one of the camp's guards.

1916–1918

After 1915, there was not much activity reported in the way of the Atlanta Ripper murders. In fact, the papers only included one major article for the whole year of 1916, and that came in December, when the *Atlanta Constitution* article "'Jack The Ripper' May Be Busy Again Assert the Police" asked the question: "Is 'Jack the Ripper' Busy Again?" Apparently, police received word at their headquarters that screams had rung out in the night near Oglethorpe Street. Someone had phoned in the disturbance to police and claimed that the screams sounded as if a woman were being killed. The tipster mentioned that the screams came from the direction of the woods.

Police searched the area as best they could, but due to the many holes and the dense bushes in that wooded area, their search was incomplete. The article did not mention if further searches would be conducted, but it did state that the area from which the screams emanated was the area where many of the Ripper murders had taken place. Once again, the pall of the Atlanta Ripper hung heavy over police as they searched the area and as the incident was reported in the press.

So, too, did it hang heavy when, on June 26, 1917, a small blurb appeared in the *Atlanta Constitution* about the discovery of another body. The small paragraph at the bottom of the page read:

> *County police are carrying out a rigid investigation of the death of the negro woman who was found Saturday night in a secluded woody spot past Pittsburg, near the railroad tracks of the AB&A road. The body*

of the murdered woman is at a negro undertaking establishment. It has never been identified. The details of the murder bring to mind the string of terrible "Jack the Ripper" murders which occurred two years ago, in which a number of Atlanta negro women lost their lives.

The last part of this article expressed a sentiment that was becoming quite common in reports of the murder of young black women. Whether they were related to the string of Ripper murders, as long as they were similar, they were tagged with that moniker.

In 1918, another possible victim of the Ripper was found. Near Grant Street, the body of a young black woman turned up in a densely wooded area. People who lived nearby found her body on the afternoon of Sunday, March 17—St. Patrick's Day. It was thought that the woman had been killed late that Saturday afternoon or early Saturday night. Her neck had been stabbed with a sharp instrument, and the ground near her corpse was thickly coated with blood. Near her lay a small penknife, half open; however, the investigating officers did not feel that it was the murder weapon. The woman was said to be about five and a half feet tall and weighed 130 pounds. She was a mulatto, with a smidgen of gray hair near her temples. The last paragraph of the article is what makes it clear that police felt this was yet another Ripper murder: "Detectives state that about five years ago during the Jack-the-Ripper excitement when so many negro women were found murdered, that a body was found almost exactly at the same spot and no clue was ever found to the crime."

1920s

The next few years were relatively quiet, but shortly after 1920 arrived, a suspect was apprehended. According to the article on February 27 titled "Alleged 'Ripper' Tried," a suspect by the name of John Brown was being put on trial for the murder of a young black woman named Laura Blackwell. Blackwell had been employed at the Fulton County Courthouse. The article read:

Beyond 1911

> *Brown is accused of one of the "Jack-the-Ripper" murders which puzzled the police about two years ago. The woman was found in an alley in the rear of East Fair Street with her throat cut and head crushed, wounds similar to those inflicted on several other negro women, victims of Jack-the-Ripper.*

Two days later, the papers reported that Brown had been convicted of the Blackwell murder and received a sentence of life imprisonment. He had apparently cut Blackwell's throat and crushed her skull with an axe. This marked the second time he was tried for the murder, as the first trial was negated and a new one granted by Judge B.H. Hill. Police mentioned that they thought he might be guilty of other murders linked to the Ripper, but the only conviction mentioned was for the murder of Laura Blackwell.

By the early fall of that year, another suspect had been captured. Claud Alexander, a black man who lived at the corner of Garibaldi and Mary Streets, was arrested by city detectives in connection with the September 1920 murder of Chattie Worsham, age twenty-nine, of Lowe's Alley earlier that week. Once again, as they arrested the suspect and began their investigation, they felt they had caught the Ripper. However, no more mention of Alexander is made, and no details are given about the investigation and subsequent arraignment.

As is evident with some of these reports, the names of further victims were revealed. The papers did not make mention of Chattie Worsham's and Laura Blackwell's murders prior to the arrest and/or conviction of the suspects charged with their murders. What is interesting about the apprehension of Claud Alexander, however, is that he lived on Garibaldi Street, where, on May 29, 1911, Belle Walker was killed. Was Alexander her murderer as well?

For the next four years, the murders seemed to cease, but on May 5, 1924, the *Atlanta Constitution* ran a story about another murdered woman who was being touted as the next victim of the Ripper. The twenty-five-year-old woman was found dead on the Southern Railroad tracks early on a Sunday morning between Peyton and Chattahoochee Stations. Lieutenant J.M. Carroll, longtime sleuth in Fulton County, found the woman lying alongside the railroad line with a knife wound in the temple.

He said that there was also evidence of a scuffle. The paper mentioned that the crime was reminiscent of the "operations in and around Atlanta a number of years ago of a mysterious 'Jack the Ripper' who was credited with more than a dozen murders." The murder of this woman and the first suspected Ripper murders were separated by more than fourteen years. If the Ripper indeed had a hand in this murder, his might well be one of the longest-running murder sprees in the United States. No more mention of this victim was made in the paper.

Over the years, the murders ceased, and there was very little talk of the Atlanta Ripper. In just a few short years, the nation would be in the throes of the economic slowdown called the Great Depression, and the crime spree that shook Atlanta in the early decades of the twentieth century would be a distant memory. No more mention of the crimes was made, and as the city began to grow and rebound from the Depression, much changed—most for the better.

5
THEORIES ABOUND

Although the Atlanta Ripper murders faded into history and did not receive much attention after the 1920s, they are still the subject of some discussion and debate. There are those who discuss the causes of the murders, as well as why they were able to remain unsolved.

One of the most commonly asserted theories is that there never was an Atlanta Ripper. By this, the proponents of the theory do not insist that the murders never happened or that they were all fabricated by the press and police; rather, they suggest that there was never a serial killer who could carry that moniker. In fact, these proponents claim that while there were a few murders in the beginning that seemed to have similar characteristics, the later ones were simply perpetrated by copycats. Steven Fennessy, whose article in *Creative Loafing* in 2005 can be said to be the best early piece on the Atlanta Ripper—discusses that theory. He even provides an expert in the field who elaborates on it.

Dr. Vance McLaughlin, who at the time the article was published was a professor of criminal justice at the University of North Carolina at Pembroke, was quoted in the article. Fennessy writes, "McLaughlin says the hysteria created by the murders may have inspired a copycat killer. Or it's possible that someone with murder on their mind simply used the same technique that was described in the papers to divert suspicion to a nonexistent serial killer." McLaughlin—who is now a professor of criminal justice at Jacksonville State University in Jacksonville, Alabama,

holds a master's degree in criminology from Florida State University and a PhD in the field of criminal justice planning from Penn State—discovered the Atlanta Ripper murders as he was conducting research for his book *J. Frank Hickey: The Postcard Serial Killer*, published by Avon Books in 2006. McLaughlin has done extensive research in the field and at one time was a police officer in Savannah, Georgia. He is a recognized expert in the field of homicide studies and has been involved in various homicide cases and investigations across the country. He went on to say in Fennessy's report, "If you were going to kill a black woman during that time, you'd certainly do the modus operandi and everything else. So was it actually one person who picked up on it, or maybe a couple of people who wanted to get rid of certain folks?"

McLaughlin has a valid point. Looking back at the murders, there were a few people who were brought in on suspicion of murder. Among those were Henderson and Huff, both of whom were not convicted. But there were also suspects who were brought in because they were accused of killing their wives—or attempting to, at least. Specific reference is being made to Charles McNeal, who murdered his wife, Lucinda McNeal, by slashing her throat and almost taking her head completely off; Charlie Owens, who killed his wife, Alice Owens, by cutting her throat from ear to ear; and Louis Drake, who attempted to kill his wife, Anna Drake, by cutting her in the back, arm and thumb. She survived—something that unfortunately cannot be said of Owens and McNeal. The point here is that these were men who killed, or attempted to kill, their wives in much the same way as the supposed Ripper killed his victims.

Were they the only ones? Was it possible that there were more than just these three who had read of previous murders and decided to take care of their wives in the same way, making it look like it was part of a series, as Dr. McLaughlin suggested? While it is true that Charles McNeal committed the murder of his wife early in 1911, it cannot be forgotten that many feel that the Ripper murders started as early as 1909. While most of those women died of gunshot wounds, one—Rosa Trice, who died early in 1911—was killed with a knife and a heavy object used to smash the side of her head. Her murder was perhaps one of the most grisly. The world may never know if McNeal tried to imitate the murderer of Rosa Trice or if the other men arrested for the murders

Theories Abound

of their wives were trying to copy the Ripper, but the argument can be made that they were.

It is true that many of the women who died were single, but that does not mean that they did not have romantic relationships. One such example was Martha Ruffian. Police actually verbalized their suspicion that her romantic relationship with Alex Smith might have had something to do with her death. This begs a couple of questions: First, was it possible that the Ripper murders were actually the work of many men? Second, could they have been carried out to *look* like they were the work of the previous murderer(s) so as to throw off suspicion? These are definitely worth pondering.

Another theory—the more popular one—is that the murders were indeed the work of a serial killer. The men who were caught for the murder of their wives were copycats, but the brunt of the murders was committed by the same man. Once again, there is room for discussion, and this argument can also be made with merit. To defend this proposition, one can first look at the manner in which most of the murders took place. There were quite a few commonalities. First, all of the victims were young, African American or mulatto women. Most of the victims were domestic servants and were either en route to their places of employment or on their way home from there. Also, most of the victims were assaulted under the cover of darkness in the late hours of night or the wee hours of morning. Additionally, most of the victims were killed by having their throats slashed or their heads bashed in—and sometimes both. The murders also took place in proximity of one another. From the research, it appears that the Old Fourth Ward, railroad tracks and impoverished black neighborhoods were the venues of choice for the murders. With these things in common, it is more than plausible to think that a serial killer was on the loose.

In addition, it also makes sense to examine the term "serial killer" itself. Before doing so, it should be recognized that the term "Ripper" was applied to the killings by the press and was also quite frequently used by local police. The reason for such a name, as mentioned before, goes back to the Jack the Ripper phenomenon in London that captivated the world just a few years before the rash of killings took place in Atlanta. But the idea of a serial killer deserves even more scrutiny.

Much research has been done as of late on the theory of serial killings. Criminologists, psychologists and sociologists have made careers

out of researching the traits of serial killers. Much of the research has been done after a killer has been apprehended, but that evidence can still shed light on cases in which the killer is still at large. For example, according to Richard Whittington-Egan, a crime writer, criminologist and, coincidentally, a Jack the Ripper researcher and scholar, there are some common traits among serial killers, and some of them seem to be relevant to the Atlanta Ripper saga. First, serial killers kill for sexual reasons, and sometimes those reasons are repulsive. Is it any coincidence that most of the victims in this case were young women, many of whom were identified as being attractive by their friends and families? Also, as some psychologists and criminologists have asserted, murders in which the attacks are brutal often indicate crimes of passion where the killer knows the victim well or has a sexual attraction to the victim or the victim's type. In many of the murders, not only were the throats slashed and the heads bashed in—both of which are brutal ways to kill in and of themselves—but also the victims often suffered even worse fates. For example, in one or two instances, the killer removed parts of the insides of the victim. In one instance, the killer cut the victim's breast, and yet another victim lost a finger when the killer cut it off at the joint.

In addition, Whittington-Egan asserts in his article "The Serial Killer Phenomenon" that serial killers usually kill intra-racially. That is, they usually kill victims of their same race. In these murders, eyewitnesses, some of whom were potential victims (Emma Lou Sharp, for one), said that they saw a tall, slender, black man. Never did any of the eyewitnesses say they saw a white man. It was never even alluded to in their statements. Furthermore, serial killers, according to the same article, most often return to the scene of the crime. They are either checking on the progress of police or are getting some sort of charge out of being in the place where they committed a crime without getting caught. The Atlanta murders mostly took place in proximity to one another; in fact, some took place on the same block. Was it possible that the killer went freely to the areas of his former killings? If the killer was living in that area, it would have been very easy for him to visit the scene of his crimes.

Another trait that is said to be common to serial killers includes the cowardly act of knocking the victim unconscious before the brutality of the attack occurs. Was that why so many of these women had head

Theories Abound

trauma? Was the killer doing what came naturally to him and knocking his victims unconscious before he cut them up and mutilated their bodies? Today, forensic science has reached the point where medical scientists can tell if a cut has been made on the body before or after death. It was not possible to make that call in 1911 or 1918, or anytime during the Atlanta murders. But what is for sure is that on many victims there were multiple injuries that could have led to death—i.e., a slit throat and a bashed head. There are a number of reasons for that. The knocking-the-victim-unconscious theory is just one possibility.

Perhaps one of the most interesting characteristics of serial killers is that they like to have souvenirs from their murders. Some killers will take articles of clothing, valuables they do not plan to sell or even, most grisly, body parts. In the case of the Atlanta murders, several of the victims had their shoes removed. In one case, the finger of the victim was cut off. Perhaps the Atlanta killer took things from the victims that were not reported by the press or that police had no idea had been taken. But the very fact that the killer took shoes from at least two victims is enough to raise suspicion in this area.

The last theory is the most interesting. As mentioned before, the murder of Mary Phagan occurred right in the middle of the killing rampage in Atlanta. In an interesting twist to both that story and the Atlanta Ripper story, detectives hired by the Leo Frank team from the famed Pinkerton Agency claimed that the black man, Jim Conley, who claimed that Leo Frank had asked him to help dispose of Phagan's body, was actually the killer of Mary Phagan *and* was the Atlanta Ripper. Very little was offered in the way of proof, but it can only be imagined that the detective asserting this, W.J. Burns, was privy to the stories in the popular press about the Ripper murders and had been apprised of the situation by local folks. Conley was a tall, slender black man and fit the description of the assailant given by both Emma Lou Sharp and Mary Yedell, both of whom were attacked by the Ripper but lived to tell their stories.

Was this just an overzealous detective's attempt to free his client by casting aspersions on an innocent man or had Burns found out something that police could not seem to uncover? If the latter was indeed the case, then most assuredly the police would have pursued the evidence—or would they? If by doing so they were going to contribute to the acquittal

of Leo Frank, perhaps they might not have. This is not meant to assert that all Fulton County and Atlanta police officers of that time were dishonest, or even that a significant number on those police forces were such. But it must be remembered that police work is also very political; the gumshoes on the streets are not totally in charge of what happens with their investigations, nor do they have much say in what is done with the evidence they collect. It is important to reemphasize that the Leo Frank trial was highly politically charged. If Burns was telling the truth, or if he had stumbled on credible evidence, it might very well have been pushed aside due to the fact that if Conley could be pinned with those crimes, it might lead juries to believe he was guilty of the Mary Phagan killing, even if the evidence in that case did not point to it beyond the shadow of doubt.

While these are just theories, they are all based on some form of evidence. It is almost impossible to piece together the story of these murders, much less settle on a specific theory that addresses who, what and why. It has been a long time since the killer, or killers, took to the streets. Although forensics has come a long way, too much of the evidence has been lost, and time has almost erased the murder sites. Most of them are paved or built over. Like the murders of Jack the Ripper in London, we may never know the truth behind this grisly time in Atlanta's history.

Epilogue

Today, Atlanta is a bustling city. The skyline reflects the modern growth of a southern metropolis touted as the capital of the New South. There are millions of people who live in the city's metro area. With the 1996 Olympic Games, Atlanta entered the international arena, and it is still there. It has changed in the last one hundred years. Of course, every place has changed in the last one hundred years, but Atlanta has seen more than its share.

The Atlanta of the Ripper murders would be almost unrecognizable to modern city dwellers. Sure, some of the same skyscrapers still occupy parts of the Atlanta skyline, but it is what is beneath those ledges and rooftops that has changed the most. Henry Hugh Proctor, Alonzo Herndon, Henry Rucker, Moses Amos and Dr. W.E.B. Du Bois were some of the most notable people to have ever called the Gate City their home. Dr. Du Bois, a legend in his own time, had more education than almost any white denizen of the city. He had read books that some governors of Georgia, mayors of Atlanta and wealthy white business owners had never read. He had seen American society in several different areas of the country, whereas many of the white citizens of Atlanta had never even been out of the state. But he could not sit in the same area of the streetcars that crisscrossed the city as the white citizens. He could not sit in the same barber chairs, eat at the same lunch counters or drink from the same fountains. He had a PhD from Harvard, but he could not teach at Georgia Tech or Emory.

Epilogue

Alonzo Herndon was such an astute businessman that he built an insurance empire, lived in a mansion and had white servants. But he was not welcome in the same business and civic clubs as Captain English, Asa G. Candler, Hoke Smith or Courtland Winn.

Not a person in 1911 would have considered that Atlanta could have a black mayor. The large churches of Atlanta mostly had white pastors, but many of them didn't have the education that Henry Hugh Proctor had. Black students could not enroll at Georgia Tech. Fortunately, there was Spelman, Morris Brown, Clark College, Morehouse and Atlanta University for the burgeoning young black scholars. Atlanta was truly two cities. It even appeared that the Ripper was working along segregated lines. None of the victims was white.

Yes, Atlanta has changed in these last one hundred years. Indeed, Atlanta could have a black mayor, and since the early 1970s, it has, with Maynard Jackson becoming the first. In fact, Atlanta's airport, the busiest in the world, bears his name: Hartsfield-Jackson Atlanta International Airport. Not only do black students apply to Georgia Tech, Kennesaw State, Emory and Agnes Scott, but they are also admitted and graduate alongside their white classmates. The Atlanta University Center, which includes not only its namesake but also Morehouse, Morris Brown and Spelman, has become the talk of black higher education, but surprisingly, if a visitor were to tour those campuses, he would also see white students there. In fact, just a few years prior to the publication of this book, the valedictorian at Morehouse College was a young white man: Joshua Packwood. However, he wasn't the first white student to attend the historically black men's school. The first was in 1966, just two years after the landmark Civil Rights Bill.

And speaking of civil rights, Atlanta became the home of the civil rights movement. It was home to Dr. Martin Luther King Jr., Julian Bond, Ralph David Abernathy, Andrew Young and John Lewis, all of whom replaced Henry Hugh Proctor, Alonzo Herndon and Henry Rucker as the faces of black Atlanta. But unlike these men, the new faces of black Atlanta would be seen and known by the entire world. The world would witness one of these men, Dr. King, make a speech from the Washington Mall and then win the Nobel Peace Prize. Yes, those names are familiar to Atlantans if for no other reason than they appear on several major street signs in the city.

Epilogue

The Atlanta of 2011 attracts hundreds of thousands of white and black tourists each year to the Martin Luther King Jr. National Monument, a place that many may be surprised to know is actually a national park governed by the U.S. Department of the Interior. If Hoke Smith were alive today, he would not believe this. Perhaps neither would Courtland Winn, Asa Candler, Captain English, Clark Howell or the Inman family. Not that these people were all racists who never wanted to see black people prosper, but their Atlanta was quite different. So was Reverend Proctor's and the other black leaders'.

Atlanta has always been a fascinating place, and for anyone who treasures the study of southern history, urban history and African American history, Atlanta is certainly a worthy subject. It has also had its share of crime. Names like Wayne Williams, Leo Frank, the DeFoors and Mary Phagan come to mind when discussing the stories of crime in the capital of Georgia. However, not many people speak about the murders known as the Atlanta Ripper Murders. It is not that they wish to sweep it

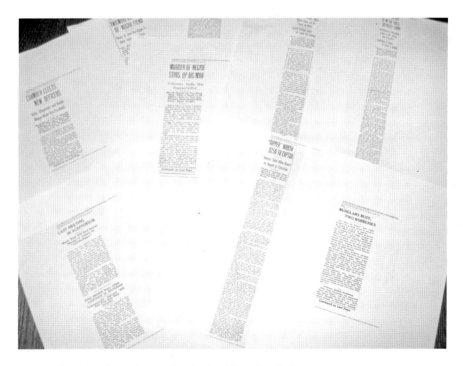

Copies of articles about the murders in the *Atlanta Constitution*.

Epilogue

under the rug, as is often the case with controversial topics such as slavery, the Atlanta Race Riots of 1906 or the racial politics that divided the state along color lines. It is just that most people have never heard of these murders. Mention the name Ripper, and you will quickly see a smile and then hear remarks that center on a famous killer in London. But Atlanta had its own Ripper killings. It is nothing of which to be proud, but it is something that should be discussed.

Yes, these murders should be discussed for what they are. Coming on the heels of the 1906 race riots that rocked the city, these murders, as ghastly as they were, brought a community to its knees. Just a few years after they started, the Mary Phagan murder would grab the attention of the city and the rest of the world, but that does not diminish their importance. For a few years, the city was gripped with fear because of the possibility of a black serial killer. There would be another some sixty years later at the heart of the Atlanta Youth Murders, but most people think of that murderous episode as the first in the black community of Atlanta. But it wasn't.

The Ripper murders not only brought fear to Atlanta, but they also brought a bit of white and black civic cooperation. Sure, the Youth Murders included the assistance and cooperation of both black and white Atlanta, but that was in the 1970s and 1980s, after the civil rights movement and the election of a black mayor. The Ripper murders did so, although to a lesser degree, in the era before Dr. King and the other famous civil rights crusaders of the 1950s and '60s were born. It is remarkable that the city and the governor's office offered rewards for the capture of the killer, that the Atlanta Chamber of Commerce stepped to the forefront in encouraging the white leadership of the community to take action—and take it in a hurry—and that petitions in the black community were signed and supported by some of the most prominent members of the white community. No, race relations were not where they needed to be at that time, nor were they where they needed to be right afterward, but the strides made during this epoch, although small, are still noteworthy.

In addition, the murders showed the pride and resilience of the black community. It was no time before the clergy and black business community stood up for peace, order and safety in Atlanta, not just

Epilogue

in their community but also for all people on the city's streets. Black Atlanta had taken a "licking" in the wake of the 1906 riots, so the string of killings during the Ripper murders was the proverbial "salt in the wound." Still, the black community weathered it well. A century has passed since these murders grabbed headlines, and Atlanta is known as a city that has come to grips with its history. Sadly, the brutal slaying of dozens of young black women in the years between 1909 and the early 1920s is part of that history.

Notes

Introduction

Ambrose, Andy. "Atlanta." *New Georgia Encyclopedia*. www.newgeorgiaencyclopedia.com.
Fennessy, Steve. "Atlanta's Jack the Ripper: Did a Serial Killer Murder 20 Women a Century Ago." *Creative Loafing Atlanta*. www.clatl.com.
Sullivan, Buddy. *Georgia: A State History*. Charleston, SC: Arcadia, 2003.
Underwood, Corinna. *Murder and Mystery in Atlanta*. Charleston, SC: The History Press, 2009.

Chapter 1

Alridge, Derrick P. "W.E.B. Du Bois in Georgia." *New Georgia Encyclopedia*. www.newgeorgiaencyclopedia.com.
Ambrose, Andy. "Atlanta." *New Georgia Encyclopedia*. www.newgeorgiaencyclopedia.com.
Burns, Rebecca. *Rage in the Gate City: The Story of the Atlanta Race Riot*. Cincinnati, OH: Emmis Books, 2006.
Kuhn, Clifford, and Gregory Mixon. "Atlanta Race Riot of 1906." *New Georgia Encyclopedia*. www.newgeorgiaencyclopedia.com.

Gallego, Mar. "W. E. B. Du Bois." *American Mosaic: The African American Experience*. ABC-CLIO.

Henderson, Alexa Benson. "Atlanta Life Insurance Company." *American Mosaic: The African American Experience*. ABC-CLIO.

Hepburn, Lawrence, ed. *Contemporary Georgia*. 2nd ed. Athens, GA: Carl Vinson Institute of Government, University of Georgia, 1992.

Hickey, Georgina. "African American Migration: Atlanta, Georgia." *American Mosaic: The African American Experience*. ABC-CLIO.

Chapter 2

"Illustration Depicting Jack the Ripper Attacking a Woman." In *Crime and Punishment: Essential Primary Sources*. Edited by K. Lee Lerner and Brenda Wilmoth Lerner. Detroit, MI: Gale, 2006.

"Jack the Ripper murders." *World History: The Modern Era*. ABC-CLIO, 2011.

Rubinstein, William D. "The Hunt for Jack the Ripper." *History Today* 50, no. 5 (2000): 10.

Wilson, Colin, and Damon Wilson. *The Mammoth Encyclopedia of the Unsolved*. New York: Carroll & Graf Publishers, Inc., 2000.

Chapter 3

Atlanta Constitution. "Another 'Ripper' Suspect Caught: Ed Ward Is Alleged to Be the Murderer of Sophie Jackson." July 23, 1911.

———. "Burglars Busy; Two Robberies." July 15, 1911.

———. "Chamber Elects New Officers." July 13, 1911.

———. "City News." *The Atlanta Constitution*. August 5, 1911.

———. "For 'Jack the Ripper' Negroes Offer Reward." July 10, 1911.

———. "Hand of God as Seen in Work of the Ripper." July 17, 1911.

———. "'Jack the Ripper' Again Has Center Stage: One Negro Being Tried for Crime, and Another Just Indicted." November 29, 1911.

———. "Jack the Ripper Case Discovered in Waycross." November 21, 1911.

Notes

———. "Jack the Ripper Takes Toll Again: Zella Favors Is Dying from a Crushed Head and Knife Wounds." December 8, 1911.

———. "'Jack the Ripper' Will Be Subject of Sermon." December 10, 1911.

———. "Last Meeting in Auditorium." July 17, 1911.

———. "'Mary The Ripper' Has Jack Beaten to a Fare-Ye-Well." July 18, 1911.

———. "Meeting to Protect Women from Ripper." July 17, 1911.

———. "Murder of Negro Stirs Up Big Mob: Policeman Hollis Was Reported Killed." February 4, 1911.

———. "Negro 'Ripper' Is in the Toils, So Police Think." July 13, 1911.

———. "Negro Shoots a Woman and Makes His Escape: Rosa Rivers, the Victim, Is Dying at the Grady Hospital." May 8, 1911.

———. "Negro Woman Is Found Murdered Near Home." January 13, 1911.

———. "Negro Woman Killed; No Clew to Slayer: Was Found with Her Throat Cut Near Her Home." May 29, 1911.

———. "Negroes Know More Than They Tell, Say Sleuths." November 23, 1911.

———. "Police Dragnet Getting Results: Officers Believe They Have Made Two Important Captures." July 17, 1911.

———. "Reign of Crime Grips Atlanta; Police Defied; Homes Are Robbed, Negro Women Slain, and No Arrests Are Made." July 12, 1911.

———. "Reward Is Offered for Jack the Ripper." July 4, 1911.

———. "Ripper Claims Another Victim." November 12, 1911.

———. "'Ripper' Is Busy in Atlanta Again: Another Negro Woman, the Ninth Victim, Found Dead." September 2, 1911.

———. "'Ripper' Is Using Heavy Bludgeon: Cook for Inman Park Family Is Found with Head Crushed In." October 18, 1911.

———. "'Ripper' Worth $250 to Captor: Governor Smith Offers Reward on Request of Committee." July 14, 1911.

———. "Todd Henderson Held as 'Jack the Ripper.'" July 18, 1911.

———. "Two More Victims of Negro Fiend: Theory of Jack-the-Ripper Is Given Further Substance." July 12, 1911.

NOTES

———. "Women Are Urged to Stay at Home." November 27, 1911.

Fennessy, Steve. "Atlanta's Jack the Ripper: Did a Serial Killer Murder 20 Women a Century Ago." *Creative Loafing Atlanta*. www.clatl.com.

Luker, Ralph. "Proctor, Henry Hugh." *American National Biography Online*. www.anb.org.

CHAPTER 4

Atlanta Constitution. "Alleged Atlanta 'Ripper' Is Now Behind the Bars." September 22, 1920.

———. "Alleged 'Ripper' Caught by Tracks Found Near Body." July 30, 1914.

———. "Alleged Ripper Convicted." February 29, 1920.

———. "Alleged 'Ripper' Given His Freedom." October 19, 1912.

———. "Alleged 'Ripper' Tried." February 27, 1920.

———. "Amateur 'Ripper' Uses Knife on Wife." July 25, 1914.

———. "Another Victim Taken by 'Jack the Ripper.'" July 19, 1915.

———. "Blood Flowed in a Crimson Stream During Year 1912: Fifty-Five Murders and Killings Occurred in Atlanta." January 1, 1913.

———. "Husband of Victim Held as the 'Ripper.'" February 20, 1912.

———. "Jack the Ripper Believed to Be a Modern Bluebeard With 12 Wives as Victims." August 11, 1912.

———. "'Jack the Ripper' Is Busy Once More: Another Negro Woman Found Mysteriously Murdered in Woods." July 22, 1914.

———. "Jack the Ripper Is Once More at Work; Third Victim Found." March 11, 1913.

———. "'Jack the Ripper' May Be Busy Again, Assert the Police." December 17, 1916.

———. "'Jack the Ripper' Threatens Invasion of Gainesville." February 18, 1912.

———. "Jack the Ripper Turns Up Again: Lures Girl to a Lonely Spot and Then Murders Her." April 8, 1912.

———. "Little Locals about Things of City Interest." June 26, 1917.

———. "Many Stolen Articles Recovered in Palmetto." March 20, 1914.

———. "Mrs. Grace's Maid Is Murdered; Eighteenth Victim of 'Ripper.'" August 25, 1913.
———. "Negress Found Dead, Believed to Be Victim of 'Jack the Ripper.'" September 6, 1915.
———. "Negress Is Found Dead on the Scene of the Ripper Murder." March 11, 1918.
———. "Negress Murdered; Ripper Suspected." August 7, 1912.
———. "Negro Woman Slain by Jack the Ripper Found Early Sunday." July 27, 1914.
———. "New 'Jack the Ripper' Now Held on the Charge of Robbing High School." March 19, 1914.
———. "Police Find Victim of Another 'Ripper.'" May 5, 1924.
———. "'Ripper' Busy Again: Another Negro Woman Victim of the Slasher." August 16, 1915.
———. "Ripper Jack Is Declared a Myth." March 3, 1912.
———. "Sixteenth Victim of 'Ripper' Found." February 17, 1912.
———. "Ultimatum Issued by Jack the Ripper: Threatens Pawnbrokers and Women Vagrants in Card Pinned on Fire Box." March 8, 1914.
Dinnerstein, Leonard. "The Leo Frank Case." *New Georgia Encyclopedia*. www.newgeorgiaencyclopedia.com.
Fennessy, Steve. "Atlanta's Jack the Ripper: Did a Serial Killer Murder 20 Women a Century Ago." *Creative Loafing Atlanta*. www.clatl.com.
Underwood, Corinna. *Murder and Mystery in Atlanta*. Charleston, SC: The History Press, 2009.

Chapter 5

Fennessy, Steve. "Atlanta's Jack the Ripper: Did a Serial Killer Murder 20 Women a Century Ago." *Creative Loafing Atlanta*. www.clatl.com.
Underwood, Corinna. *Murder and Mystery in Atlanta*. Charleston, SC: The History Press, 2009.
Whittington-Egan, Richard. "The Serial Killer Phenomenon." *Contemporary Review* 290, no. 1690 (Autumn 2008): 323–30.

Further Reading

The following is offered as a suggested reading list for those interested in finding out more about Georgia history, Atlanta history and crime in Atlanta. As with any bibliography, this list is not meant to be exhaustive. These books will help the reader develop a better foundation for understanding the environment and era in which the Ripper crimes were committed in Atlanta. In addition, some titles about other sensational crimes in the city have been included.

Atlanta History

Allen, Frederick. *Atlanta Rising: The Invention of an International City*. Atlanta, GA: Longstreet Press, 1996.
Burns, Rebecca. *Rage in the Gate City: The Story of the 1906 Atlanta Race Riot*. Cincinnati, OH: Emmis Books, 2006.
Davis, Harold Eugene. *Henry Grady's New South: Atlanta, a Brave and Beautiful City*. Tuscaloosa: University of Alabama Press, 1990.
Garrett, Franklin Miller. *Atlanta and Environs: A Chronicle of Its People and Events*. Athens: University of Georgia Press, 1954.
Pomerantz, Gary. *Where Peachtree Meets Sweet Auburn*. New York: Scribner, 1996.

GEORGIA HISTORY

Cobb, James C. *Georgia Odyssey.* Athens: University of Georgia Press, 1997.

Coleman, Kenneth. *A History of Georgia.* Athens: University of Georgia Press, 1991.

Dittmer, John. *Black Georgia in the Progressive Era, 1900–1920.* Urbana: University of Illinois Press, 1977.

Hepburn, Lawrence, ed. *Contemporary Georgia.* 2nd ed. Athens: Carl Vinson Institute of Government, University of Georgia, 1992.

Sullivan, Buddy. *Georgia: A State History.* Charleston, SC: Arcadia Publishing, 2003.

CRIME IN ATLANTA

Dinnerstein, Leonard. *The Leo Frank Case.* 1968. Reprint, Athens: University of Georgia Press, 1994.

Headly, Bernard. *The Atlanta Youth Murders and the Politics of Race.* Edwardsville: Southern Illinois University Press, 1998.

Jenkins, James. *Murder in Atlanta: Sensational Crimes that Rocked the Nation.* Atlanta, GA: Cherokee Publishing Co, 1981.

Mallard, Jack. *The Atlanta Child Murders: The Night Stalker.* BookSurge Publishing, 2009.

Oney, Steve. *And the Dead Shall Rise.* New York: Random House, 2003.

Underwood, Corinna. *Murder and Mystery in Atlanta.* Charleston, SC: The History Press, 2009.

About the Author

Jeffery Wells is a native Georgian. Educated in Georgia public schools, he went on to receive his bachelor's degree in history from the University of Georgia in 1996, when he graduated cum laude. In 2006, he received his master's degree in history from Georgia College and State University in Milledgeville, where he received the William Ivey Hair Outstanding Graduate Student in History award. Beginning his teaching career in 1998, Wells has taught at the middle school, high school, technical college and community college levels. Currently, he is the Social and Behavioral Sciences Division chair at Georgia Military College, where he also serves as assistant professor of history. He has authored several books on Georgia history, including *In Atlanta or In Hell: The Camp Creek Train Crash of 1900*, also published by The History Press; *Bigfoot in Georgia: Legends, Myths, and Sightings*, published by Pine Winds Press; and *Moments in McDonough History*. In addition, he is the author of several articles on Georgia history. He is a member of the Georgia Association of Historians, the Southern Historical Association, the Georgia Old Capital Museum Society, the Old Campbell County Historical Society and the Genealogical Society of Clayton and Henry Counties. He resides in metro Atlanta.

Visit us at
www.historypress.net